KITCHENER:
THE MAN, THE POSTER AND THE LEGACY

by Martyn Thatcher
& Anthony Quinn

UNIFORM

First published in 2016 by
Uniform, an imprint of Unicorn Publishing Group LLP

101 Wardour Street
London
W1F 0U

www.unicornpublishing.org

Martyn Thatcher and Anthony Quinn © 2016

ISBN 978-1910500361

Printed in Great Britain

KITCHENER:
MAN,
POSTER
LEGACY
THE
THE
AND THE

by Martyn Thatcher
& Anthony Quinn

Contents

Foreword

by Lady Kenya Tatton-Brown

At the end of the nineteenth century the poster really came into its own as a visual force before the public. So, in some ways, it is not surprising that Alfred Leete's poster depicting Herbert Horatio Kitchener, my great uncle, appealing to the nation's conscience is the main thing remembered about him.

Growing up between the wars as I did, one was very conscious of the slaughter that the nation had suffered. One learnt of the efforts Lord Kitchener made to try to reduce that destruction. His letter to General French, commander of the British Expeditionary Force, when they were about to embark for France makes it clear how much he cared for humanity.

I have often wondered whether enough thought has been given to the work that went into Lord K.'s world trip in 1910. This covered Australia, New Zealand and, on the way home, the United States of America. As evidence of the degree of his welcomes and the goodwill that resulted in the various towns and cities in those countries, there exists an amazing number of illuminated addresses from their mayors and corporations. Testifying further to these efforts are the numerous newspaper and magazine cuttings giving details of these visits and contacts with military establishments.

The service personnel from Australia and New Zealand who served overseas in the Great War were volunteers. Sadly, the battles in which they fought were not great victories, but the fact that they came to our aid so readily in time of great need should be remembered. South Africans, too, took up arms alongside British

Kitchener - The Man, the Poster and the Legacy

troops. As this book points out, the recruiting campaign was promoted by that country's prime minister, Louis Botha, who had led the Boers against the British just 15 years before. Had the terms of the Treaty of Vereeniging, signed at the end of the Second Boer War by both Botha and Lord Kitchener, not been so fair, perhaps South Africa would not have responded to the call.

Leete's recruiting poster portrayed the dynamism that was Lord Kitchener, and gives a sense of why a soldier who had never served at the War Office was selected as Secretary of State for War.

My grandparents were cousins of Herbert's and it was with them that he was staying before catching the boat at Dover to return to Egypt in 1914. Such was his popularity in the family that my aunts told me that they competed to be allowed to go and say their morning prayers with cousin Herbert; he was a devout man, who at times upset young aides-de-camp having to get up for early morning services with him.

I often felt he must have been a lonely man, shy, and no public speaker; unable to go home to Egypt to collect his belongings once he was called to the War Office, and no wife to 'pack and follow'. Of course, he was never to return to Egypt, and in the 1960s, we at last unpacked one of Herbert's cases sent on after his death in 1916. Imagine our reaction when we found one of the dinner plates was wrapped in an Egyptian newspaper, which I still have, announcing the sinking of HMS *Hampshire*. An eerie feeling.

How different history might have been had Lord K. been able to complete his voyage to Russia. Might he have been able to persuade Tsar Nicholas of the peril of his position and to take action before the revolutionaries became organised? Or, indeed, return home and tell George V how essential it was to invite the Romanov family to England as a refuge. However, hindsight is a luxury one should not indulge in often.

I hope that this book will spark interest in all the posters, and the way that they portray the charisma of Lord Kitchener.

Lady Kenya Tatton-Brown
March 2016

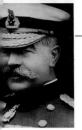
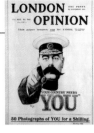
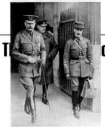
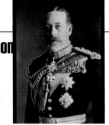

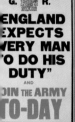
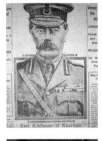
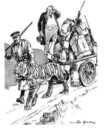
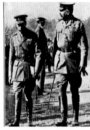
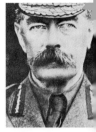

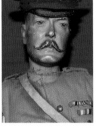

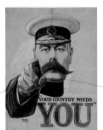
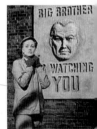

1

Preface

By Martyn Thatcher & Anthony Quinn

One hundred years ago, Field Marshal Horatio Herbert Kitchener died. He had sailed for Russia aboard HMS *Hampshire* but the cruiser hit a German mine in a storm and sank with the loss of most of the crew. Kitchener's body was never recovered.

Kitchener - The Man, the Poster and the Legacy

Reams have been written about Kitchener – much based on the biographies published soon after his death – and these were often influenced by the politics of the writers. It is not the intention of this book, however, simply to add to these biographies because something very unusual happened to Kitchener that has not been addressed fully before – over time, he morphed into a poster!

Most people today know about Kitchener through a painting with the man's pointing finger and the words 'Your Country Needs You'. It was drawn by a little-remembered artist, Alfred Leete, but he was also famous in his day. Kitchener has become Leete's poster and the words send down to us echoes of the Great War and a history that is now lost to the living memory – a world that was a very different place from the one we occupy. By 1900, Kitchener, the man, had what we would now call 'superstar' status. He was a famous field marshal who had won great battles and thousands of postcards carrying

Figure 1.

Postcard based on a Kitchener photograph taken by Bassano in 1885

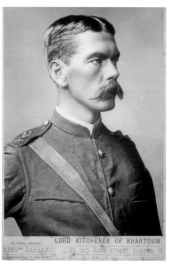

Figure 2.

Alfred Leete's iconic image on one of the Kitchener posters

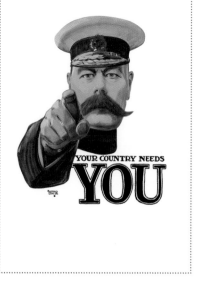

his photograph graced the mantelpieces of Victorian and then Edwardian Britain. He came to embody the virtues – and perhaps reflect the faults – of the British Empire. Some readers will recognise his face today from photographs by the society photographer Alexander Bassano between 1885 and 1890, now in the National Portrait Gallery – some of which were made into postcards (Figure 1), but it is a poster bearing his image that is most readily remembered (Figure 2).

The words and image of the Leete poster have influenced billions of people across the world for a century. They are continually repeated: in a sign seeking staff for a shop on a London high street; on a notice board in Suffolk seeking volunteers for a village fete; in the advertising for a satellite TV sitcom based around three recruitment dodgers in the First World War.

This book, we hope, will help the reader to form an opinion about the great man by exploring his popular image – the famous 'Kitchener' poster. We aim to paint a picture of the fascinating world in which Kitchener made his name, assess his career and explore how and why a magazine cover illustration, reused on a poster a century ago, lives with us still.

In writing *Kitchener - The Man, the Poster and the Legacy*, we briefly portray the lifestyles enjoyed by people at the time. In our exploration, we have encountered events that surrounded the British recruitment campaign and offer glimpses of the Edwardian era – when cars and telephones were still rare and magazines and tabloid newspapers were the new media – and so offer a perspective of events from that time.

We explore these stories to determine how Leete's artwork has become an icon of the Great War, which after 1939 would be known as the First World War, and how it has impinged upon our memories of Kitchener himself. The collections of the National Art Library at the Victoria and Albert Museum, the Imperial War Museum, the St Bride Printing Library, British Library Newspapers and the British Library have all been vital to this work. Alongside these resources, the authors' own collections of Kitchener image ephemera and magazines have also contributed.

Kitchener - The Man, the Poster and the Legacy

In 2013, various newspaper articles repeated a claim that the 'Kitchener' poster was rarely seen at the time, if at all, and became well known mainly because of its use for publicity by the Imperial War Museum. The suggestion was made in 1997 by Nicholas Hiley in the *Imperial War Museum Review* and was taken up by James Aulich and John Hewitt in their 2007 book on Great War posters and repeated by James Taylor in 2013, in his book *Your Country Needs You: The Secret History of the Propaganda Poster*. Even the venerated British Library describing the poster on its website says:

> This image, designed by Alfred Leete (1882–1933), and famous for Kitchener's pointing finger and the words 'Your Country Needs You', has become an icon of the enlistment frenzy. However, it did not appear in poster form until the end of September 1914, after signing-up peaked. Its supposedly vital influence on recruitment is largely a myth.

We feel that it does stretch the imagination to suggest that a poster so well known might not even have existed and that the written and spoken memoirs of war veterans were wrong, due, they suggest, to ailing memories. This great recruiting poster and the memories of the veterans deserve better. We have been able to challenge such ideas with solid evidence to the contrary in a comprehensive, up to date, and, we believe, unbiased, account.

In interpreting these sources and artefacts, we – and you – cannot undo the influences that have formed our thinking no matter how hard we try, so we leave you to make your own decisions as to what to accept, doubt or seek to challenge. In the end, however, you will know a lot more about Kitchener the man and his famous poster.

2

Introduction

oratio Herbert Kitchener – Lord Kitchener, Kitchener of Khartoum or K. of K. as he was known – was the most famous military man of his day. Born on 24 June 1850 in County Kerry, Ireland, he was educated in Switzerland and at the Royal Military Academy in Woolwich. He volunteered to work in a French ambulance unit in the Franco-Prussian War (1870-71) and then he joined the Corps of Royal Engineers. After survey work in Palestine and Cyprus, Kitchener spent three decades in Africa, where he avenged the death of General Gordon and re-established British rule in the Sudan, serving there and later in Egypt until 1914.

He was made a baron, appointed governor of Sudan and was firmly established as a national hero. His face was not only portrayed in newspapers and magazines, but on postcards, cartoons, badges, photographs and portraits for the home, cigarette cards, matchboxes and pottery and he was even sold in the form of several dolls – the world's first 'Action Man'. This would have been enough of a career for most people, but his greatest feat – running Britain's war effort from 1914 at the age of sixty-four – was still to come. Yet, even with that, he would probably still have joined Roberts, Haig and French as a heroic name in the history books had not a cartoonist put his face on the front of a magazine cover – and in the process turned that face into a poster and a worldwide icon.

Kitchener: the man, the poster and the legacy joins a long list books and biographies that have been written about Lord Kitchener and many of these are listed in the Bibliography. The pocket-sized *Kitchener Birthday Book* issued in

Kitchener - The Man, the Poster and the Legacy

1916 printed an event in K. of K.'s life, or a saying he had made, for every day of the year. Paintings by R. Canton Woodville and Dudley Hardy portray him at key stages in his life: in Arab dress, in Egypt, in the ruins of Khartoum, at the Durbar in Delhi, on the Western Front and at Gallipoli. Yet his private life, his persona, remains a relative mystery. Some writers have speculated about his sexuality and he did have a 'constant and inseparable companion', Captain Oswald Fitzgerald. However, we also know he came close to proposing marriage on one occasion, but that the object of his affections died of typhoid, and his family has records of an amorous relationship as a young man. In reality, his sexuality is probably the least interesting thing about Kitchener.

History has decided that his legacy is a face on a poster and it is in this form that he is most widely remembered. The irony is that the picture we have of him, the poster face, was an artist's drawing and was based on a photograph taken twenty years before 1914. Yet this poster face remains the public face of Kitchener today. In this book, we have used the Kitchener poster as a fulcrum to survey the scene in the early part of the twentieth century and develop a feeling for the environment within which a man like Kitchener would evolve. Indeed, Alfred Leete's image is an interesting phenomenon in itself and worthy of more study.

From the thousands of recruiting posters produced in the Great War, the Kitchener poster has become the icon of that conflict and we will try to suggest reasons why this has happened. The image on that famous poster, a pencil-and-wash drawing by a magazine cartoonist and commercial artist, dates back to first weeks of the Great War. It is of a moustachioed man staring straight at us, his eyes seemingly following us, his finger demanding attention. For Britons and much of the Commonwealth, that man is Lord Kitchener and the artist was the thirty-three-year-old Alfred Leete. For people in the United States, there is a pointing portrait of Uncle Sam, the equivalent for that nation of Britain's John Bull. This was produced in 1916, again for a magazine cover, by James Montgomery Flagg, an American illustrator. It was undoubtedly an interpretation of Leete's illustration. In addition to

Kitchener's poster image, some variant of the words 'Your country needs YOU' may be blazoned across the poster and in our memories. Even outside the English-speaking world, across Europe, Africa and Asia, the formulation is still familiar. This same drawing, and its many variants, with similar words, has been used to sell a multitude of goods and events from local jumble sales to cigarettes to Swinging Sixties clothes to satellite television programmes. Modern cartoonists have found the poster an irresistible and flexible subject for their own ideas. It has enjoined people to reject war, as well as fight in more than one, and to reject or accept many theories and ideas. The poster has also been described as the best and most effective poster yet seen. The illustration was created for the 5 September 1914 front cover of *London Opinion*, a weekly humorous magazine, and that rushed drawing of the austere Lord Kitchener and the four words below the original version – 'Your country needs YOU' – have remained with us.

The image was turned into a very unusual poster – advertisements usually will try to persuade you that you need the product on offer. In the case of Leete's Kitchener poster, the situation is reversed – the man on the poster is claiming to need you! Even so, much of the writing about 'the Kitchener poster' and 'your country needs you' is confused, often conflating different variations of the image and wording, and even totally different posters.

So, many questions arise. What is the power of the Leete poster? How did it come about and how did it become such a global icon? Was it widely distributed? Did the real Kitchener actually look like that? We will explore such questions and also deal with our perceptions of historical events and how, like Chinese whispers, they can change with repetition over time.

It is impossible to reach back into the minds of people in 1916. Behind many of the sources of information about Kitchener there are commercial and political interests that may have wanted to exaggerate their influence, and individuals who similarly want to expand or minimise their roles or the influence of Leete's work on their own. The government's poster campaign, its advertising propaganda and even the editors of, and contributors to, popular

newspapers and magazines can all claim to have contributed to the effort to persuade British men to volunteer for the Western Front.

Today, Alfred Leete is a rarely-heard name, but a hundred years ago he was one of the great names in an era when illustrators were as well known as the celebrity photographers and television presenters of today. Daily newspapers had only recently overtaken magazines as the latest mass media. New products, and an expanding population to consume them, generated the advertising to subsidise the cover prices of these publications. Since 1890, when Alfred Harmsworth's *Answers* magazine is reckoned to have achieved half a million sales a week, weekly magazines had developed business models that paved the way for their owners to create the next mass media and so between 1896 and 1903, daily newspapers based on tabloid journalism such as the *Daily Mail*, *Daily Express* and *Daily Mirror* arrived on the news stands. Harmsworth founded two of these and would become the newspaper baron Lord Northcliffe – and have a big influence in ensuring that Kitchener was appointed to his greatest role.

In the early twentieth century, the growth of the media was phenomenal. In 1909, mass communication was limited, but the first cinema had already been built in Britain and by 1916 twenty million people were going to the country's five thousand cinemas a year and this was becoming a prime source of public information. The idea of a national radio had yet to be voiced, and telephones were rare. Postcards provided the only means of near-instant communication for most people, with next-day delivery taken for granted with a halfpenny stamp and often more than one delivery a day. Millions of postcards were posted every week, with a boom sparked by the divided-back card with address and message on the same side, freeing up the front for a picture, from 1902.

3

Forty years
leading up to war

Central to our story is the Great War – the terrible conflict that was mostly played out within a strip of land that stretched across France from just north of Dunkirk on the Channel coast to the Swiss border – four hundred miles long, although barely a mile wide in places.

Since early 2014, the hundred-year anniversary of the start of the Great War, publishers and broadcast media have tried to bring that war back to life for their modern-day audiences. Some poignant images were republished bringing the history to a new generation. In addition, many people are likely to recall footage from the oft-repeated BBC television series *Blackadder Goes Forth* or more recently Michael Morpurgo's *War Horse* book and the play and film adaptations. These programmes and publications can only attempt to portray the true horror endured by the men who spent weeks at a time in the appalling conditions that were a daily reality in the trenches. Conditions so

Figure 3.

A 'Tommy' reflects

terrible that most men, who as a gender are usually rarely short of anecdotes about their adventures, could never discuss that period for the rest of their lives. What is most striking today is to visit one of the many cemeteries in Belgium or France – there are almost a thousand sites – with the largest, Tyne Cot near Ypres, holding almost twelve thousand graves.

Britain was continually at war throughout the nineteenth century, but since the Crimea War against Russia that ended in 1856, the hostilities had been mainly outside Europe. They involved putting down rebellious locals to cement the British Empire – the Zulu War, Abyssinia, two Anglo-Boer wars against Afrikaans settlers in South Africa, Afghanistan, Sudan and the Nile campaigns among them. The British were able to win through the application of organisational skill, with well trained, professional forces on land and sea, and with superior weapons technology. But alongside these actual wars in far-flung parts of the empire, writers were imagining how war might look closer to home, against a modern European power.

In May 1871, *Blackwood's Edinburgh Magazine* published *The Battle of Dorking: Reminiscences of a Volunteer*, a short story that was to influence public debate right up to the start of the Great War and spark a Victorian genre that was later described as 'scare fiction' and which is known to academics today as 'invasion literature'. *Blackwood's* was an influential right-wing monthly that specialised in tales of military and colonial life and was sold globally as well as at home. Today, *Blackwood's* is probably best known for establishing the careers, among others, of both *Middlemarch* author George Eliot and Joseph Conrad, whose *Heart of Darkness* it serialised in 1899. The initially anonymous *Battle of Dorking* (by army engineer George Tomkyns Chesney) describes how a secret weapon deployed by the Prussians destroys the Royal Navy, with the ineffectual defenders on land finally being defeated near Dorking in Surrey. The invading force conquers Britain and the Empire is then broken up.

The work sold more than 100,000 copies as a pamphlet and was published in a number of editions as a book and translated into several languages (Figure 4). Such was its influence that William Gladstone, the prime minister, was driven

to speak out against it. Four months after the May issue of *Blackwood's* appeared, army manoeuvres involving 30,000 men were held on the Hog's Back, a ridge between Farnham and Guildford in Surrey. Chesney went on to become a reforming general and was knighted for his work in both Britain and India. For one academic, Patrick Kirkwood:

> *The Battle of Dorking* was central to the parliamentary, military and public 'invasion' controversies of the 1870s. Subsequent developments, ranging from recurring print and parliamentary debates, to military manoeuvres and the eventual building of a series of forts along the North Downs support this position … *The Battle of Dorking* was equal parts fantasy 'invasion literature' and policy document. Its frequent citation by members of both houses of parliament, and by military men engaged in public and private debates, serves to back this claim, as does

Figure 4.

'The Battle of Dorking' was first published by *Blackwood's* magazine in 1871

Chesney's rapid integration into the pro-military reform wing of the Conservative Parliamentary Party of the 1890s.

Adding to the genre, Liverpool-born journalist Louis Tracy wrote several books about future war, the best known being the 1896 *Final War*, a book dedicated to 'Private Thomas Atkins' (a nickname for the average British soldier that dates back at least to the time of the Battle of Waterloo – from which we get 'Tommy'). He saw his work as describing 'a great war to be the end of all

war' and it ends in victory for the British with the help of the United States against the Germans and French. Tracy's books include elements of science fiction, with a British secret weapon, the 'Thompson Electric Rifle', helping ensure victory.

The invasion theme was taken up by H.G. Wells in his *War of the Worlds*, which was first published in *Pearson's Magazine* in parts from June 1897. For Wells, the enemy comes from another planet and, though the aliens easily overwhelm the defenders, they are ultimately defeated (by nature, in the form of bacteria). As with Chesney's book, the Surrey stockbroker belt is pivotal, with the Martians landing on the edge of the town of Woking, just fourteen miles from Dorking.

The big-selling penny weekly magazines did not miss out on the invasion theme, with Northcliffe's *Answers*, one the best-selling weeklies, serialising Frederick White's *The Lion's Claw*, which has the old enemies, the French and Russians, invading. And the next week in 1900, *Pearson's Weekly* put out one of Tracy's thrillers *The Invaders: A Story of Britain's Peril*, with the Germans as the villains of the piece. Three years later, Germany returns as the enemy when a gathering invasion force is discovered in Robert Erskine Childers' ripping yarn, *Riddle of the Sands*. Five years after that, in *War Inevitable* by Alan Burgoyne, an MP who specialised in naval affairs, a fictionalised Lord Kitchener comes to the rescue after German motor torpedo boats devastate the British fleet in a sneak attack. A year before the real war breaks out, *When William Came* by 'Saki' (Hector Hugh Munro) was published. This book follows on from Chesney's theme of forty years earlier, describing life under German occupation: the 'William' of the title is Kaiser Wilhelm II – 'Kaiser Bill' to the British people at the time. With the outbreak of the real war, a new edition of *The Battle of Dorking* was published.

Ralph Straus wrote a summary of these 'scare-fictionists' in the second issue of *Bystander* magazine after the Great War was declared. The article, 'Armageddon – in prophecy', is illustrated with a painting depicting aerial warfare by Guy Lipscombe from Burgoyne's *War Inevitable*. He discusses how 'About the middle of the century Germany definitely emerged to take

France's old place as our potential enemy' and describes how such writers 'have come to the truth'.

These fictional works spurred debate in the real world. As the new century began, Britain was the only European power that did not have a large conscript army, even though many prominent figures had been pressing for compulsory military service since the first Boer War. Among these advocates was George Shee, a barrister and Liberal imperialist, who in 1901 published *The Briton's First Duty: The Case for Conscription* in which he argued for a compulsory home defence army to protect against invasion. Despite the strength of the Royal Navy on the high seas, it could not guarantee that it would prevent an invasion force crossing the English Channel, only that it would be able to cut the invaders' supply lines. Out of the conscription movement came the National Service League, a group founded in 1902 that argued the army was too weak to fight a major war and that national service was the only answer. Boer War hero Lord Roberts later led the league and saw its membership increase from 2,000 to about 95,000 by 1913.

Alongside Lord Roberts's 'crusade' were many patriotic leagues, among which can be counted Baden-Powell's Boy Scouts – who later played a role in civil defence during the war, guarding the water supply system, running patrols from groups of twenty or thirty scouts attached to city police stations and sounding the 'all clear' on their bugles after air raids. The influence of such patriotic leagues, many of which had been in existence since before the war – the Scouting movement dates back to 1907 – was such that many thousands of youngsters had been engaged in physical activity and were trained in some kind of uniformed organisation by the time war broke out.

Britain's foreign policy changed direction during the first few years of the new century. Remember that for this generation, the Battle of Waterloo and Wellington's final victory over Napoleon's French Armies, with help from Prussian (German) forces under Blücher, was as close in time as the Great War is to us today. Nelson's Column was only completed in 1843, celebrating Vice-Admiral Horatio Lord Nelson's career and glorious death in a square named after his decisive defeat of the Franco-Spanish fleet off Cape Trafalgar on the

Spanish coast in 1805. In his compilation of reports from the *Daily Mail*, Twells Brex dates the start of the 'falling out' to 1864, when British sympathy for Denmark in the Schleswig-Holstein campaign aroused the resentment of the Prussians, as did Britain's neutrality during the Franco-Prussian war of 1870-71. Such was the feeling in Germany that Brex quotes a British ambassador saying 'it might take generations to allay the vindictiveness of the German people'.

At the international level, the balance of power was shifting. In Europe, the decisive factor was the rise of a united Germany, while across the Atlantic the United States was expanding quickly. Prussia had pushed for the unification of the Germanic states since the middle of the nineteenth century and Bismarck, the chancellor, succeeded at the third attempt in 1871. From then on, foreign policy was made in Berlin, with the German Kaiser (who was also the King of Prussia) as head of the German Empire.

After the failed Jameson raid in South Africa in 1895 – launched on 29 December 1895, when pro-British mercenaries crossed the border from Bechuanaland (Botswana) to try to spark an uprising – the Kaiser had sent a telegram to President Kruger congratulating the Boer action against 'armed bands, which invaded your country as disturbers of the peace'. Germany was also sympathetic to the Boers in the Second Boer War with Britain. In 1900, the German Navy Laws saw a great expansion in the number of warships. This military expansion was interpreted as a challenge to Britain, and the fact that Germany had made no secret of its support for the Boers caused the British attitude to Germany to change despite the many Germanic influences – such as Christmas trees – introduced through Queen Victoria's German husband, Albert, in the mid-1800s. In the Edwardian era, instead of the traditional cordiality towards Germany and fear of a combined France and Russia, the nation became more friendly towards France and Russia.

An Anglo-French agreement in 1904 – the 'Entente Cordiale' – mainly over their respective interests in Egypt and Morocco, alarmed the Germans. The question arose of what would be Britain's response should Germany attack France over a dispute about Morocco. The Tangier Crisis arose between

March 1905 and May 1906 over the status of Morocco. The crisis worsened German relations with both France and the United Kingdom, and helped cement the Entente Cordiale. One answer to the question of Britain's response can be found in the army's summer manoeuvres at the time, which considered Germany and Belgium, not France, among the potential enemies. Also in 1906, Germany felt humiliated by the Treaty of Algeciras, an international conference of the European powers and the United States, held in the Spanish city. This was called to discuss France's relationship with Morocco and temporarily settled the dispute. However, Germany was left feeling surrounded by hostile powers, a feeling that grew alarmingly after an Anglo-Russian entente later in the year. The result was to encourage a naval arms race based on ever more powerful dreadnoughts – the heavily armed and armoured battleships of the Royal Navy that revolutionised naval power when they entered into service in 1906.

Whether in fiction, or the real world, war came to be seen as inevitable for many people and the most likely enemy was Germany. The Great War broke out in August 1914, when Germany declared war, first on Russia and then France. Trouble in the Balkans, which culminated in the assassination of Franz Ferdinand, heir to the throne of Austria-Hungary, by a Bosnian Serb student on 28 June, has generally carried the blame as the spark for the Great War. Between the assassination and the start of hostilities there was plenty of time for calculation, caution and decision, but it was too late, hostilities had been brewing for a long time.

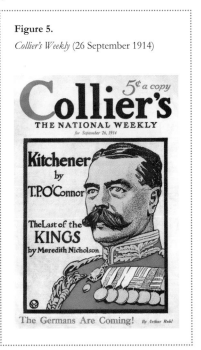

Figure 5.

Collier's Weekly (26 September 1914)

4

The Edwardian
social scene

King George V (Figure 6) came to the throne in 1910, the son of King Edward VII and Alexandra of Denmark, a sister to the empress of Russia. In 1893, George had married Princess Victoria Mary of Teck (a town in modern-day Germany) who had been engaged to his brother. The marriage was a success and George, unlike his father, never took a mistress. They had six children, Edward, Albert, Mary, Henry, George and John. They lived on the Sandringham estate in Norfolk. (It was George who would change his family name from Saxe-Coburg-Gotha to that of Windsor in 1917 as a response to anti-German public sentiment.) Alongside Mary, known as 'May', George reigned until his death in 1935.

The British Royal Family had close ties to their Central European cousins but most working people would have had little contact with anyone outside their country, or even outside their immediate area.

For the urban working classes, the music hall was the great entertainment, which provides an idea of the morality of the times and the divide between the royal circle and the people. The most popular artiste of the day was the twice-divorced Marie Lloyd but she was not invited to perform in the first Royal Variety Performance in 1912 – because she was regarded as too risqué to appear before George V and Queen Mary. Fans savoured the double entendres of her songs such as 'I sits among the cabbages and peas.'

Britain was still revelling in the glories and certainty of the Victorian era with class distinctions very much a way of life. These distinctions can be seen in the

magazines people read, such as the *Queen*. This was launched by Samuel Beaton with the permission of Victoria in 1867 and published the recipes collected by his wife – the famous Mrs Beaton. It cost a shilling (twelve pennies) a copy. Other titles included the upmarket sixpenny magazines *Tatler*, *Bystander* and *Punch*, and the popular penny weeklies *John Bull*, *Pearson's*, *Answers* and *Tit-Bits*. Somewhere in between was *London Opinion*, a title that has disappeared from common recognition, but was then a thriving success, and is of vital importance in our tale.

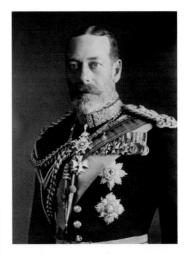

Figure 6.

King George V came to the throne in 1910

The image of the aristocracy portrayed in their magazines was one of splendid and carefree easy living, but this was a contrast to the forces of discontent and resentment felt by many other members of society. In particular, resentment among the working classes ran deep. In 1900, massive costs had been levied against the trade unions after a legal judgment in favour of the owners of the Taff Vale railway. Members of the Amalgamated Society of Railway Servants had gone on strike to protest against the company's treatment of a man who had been refused higher pay and was punished for his repeated requests by being moved to a different station. This was the catalyst for the creation of a political party that supported the trade unions. Initially called the Labour Representative Committee in 1900, it later became the Labour Party. The two established parties were the Conservatives and the Liberals. And it was a Liberal chancellor of the exchequer, the Welshman David Lloyd George, who pushed through a 'people's budget' in 1909 that proposed an income tax on the rich to pay for reforms, the introduction of social insurance and the rebuilding of the Royal Navy.

Kitchener - The Man, the Poster and the Legacy

The rise of such men as Lloyd George from humble origins to high positions in the government showed the changing nature of political life, a change that the House of Lords was slow to accept. The upper house, packed with hereditary peers, considered the people's budget to be a socialist project and rejected it. Two general elections were held to resolve the deadlock, with the Liberals finally winning a landslide victory. In the interim, the Lords continued to reject the budget, which was finally passed in 1911 when the Commons approved the Parliament Act to limit the delaying power of the House of Lords. From then on, the Lords could no longer reject bills outright and there was to be a general election every five years (instead of seven). The Liberals remained in power until a wartime coalition government was formed in 1915.

August 1911 saw great industrial unrest. Strikes of dockworkers, railwaymen and miners brought the country to a standstill. The government was forced to respond. The National Insurance Act was passed to ensure that the worker, the employer and the government all contributed to a general fund to pay for free medical treatment, sick pay, disability and maternity benefits. It also introduced a measure of unemployment benefits, and free meals for school children as well as periodic medical examinations. Through the efforts of Winston Churchill, labour exchanges were set up where unemployed workers could sign on for vacant jobs. The foundations were being laid for a sea change in the state's responsibility for the welfare of its citizens. Although there were strikes through the war, they were far fewer.

That same year, Irish MPs who had helped the Liberals gain power wanted their reward in home rule. To the Conservatives, however, the idea of Britain splitting up (in the face of a hostile Germany) seemed ludicrous, and was to be avoided at all costs. The Conservatives were aided by the Protestant forces of Ulster, equally alarmed at the prospect of being ruled from Dublin. Civil war loomed in Ireland, and some Irish-born British army regulars made it clear in the so-called 'mutiny' at the Curragh, that they would not fight against their brothers in Ulster. The outbreak of war altered Irish attitudes. The suddenness of the change was alluded to in a *Bystander* cartoon of 19 August 1914 by

Francis Rigney, 'The change in Ireland'. As can be seen in Figure 7, three frames show an Ulster Volunteer and a Nationalist Volunteer both about to start a fight with John Bull over home rule, when the Kaiser approaches in a boat – and they both head off to battle the invader. 'Of all the impudence – let me at him' cries one; 'Will you do me a favour John? Just let me get one clout,' cries the other as John Bull looks on nonplussed. In September, the Home Rule Bill was finally pushed through, though its implementation was delayed. In between, this crisis blew up on 24 April 1916 with the Easter Rebellion in Ireland.

It can never be known what would have happened in the workplace and in Ireland had hostilities not begun in Europe in the summer of 1914. Statistics show the level of industrial discontent at the time. In 1911, 9 per cent of the total industrial population was involved in strikes, compared with 2.6 per cent for 1902 and an average of 2.9 per cent for the period. Yet, a *London Opinion* cartoon by Bert Thomas, 'The tolerated tiger', eight months into the war shows a tiger marked 'Socialism' hauling a cart of provisions for a soldier off to war (Figure 8). A box on the cart is marked 'ASC', for the Army Service Corps. An onlooking figure representing a confused capitalist system comments: 'To think I should have lived to approve the harnessing of the Socialist tiger to the nation's needs.'

Even in the world of toys, martial values came to the fore during the Great War. The Kitchener 'Action

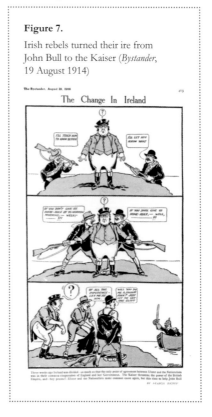

Figure 7.

Irish rebels turned their ire from John Bull to the Kaiser (*Bystander*, 19 August 1914)

Figure 8.

The Socialist tiger is harnessed to the nation's needs

Man' (Figure 9) was part of the 'Patriotic' series made in the Lord Roberts Memorial Workshops, which were set up to employ disabled soldiers and sailors. The officer's cap, tunic and knee-length breeches were made from khaki cotton drill, with nickel-plated paper fasteners for buttons, a leather Sam Browne belt and holster, red felt collar tabs and scrap medal ribbon sewn on the left breast to represent Kitchener's medals. Some of the dolls also wore a trench coat. The charity had its main workshop in Fulham and a showroom at 122 Brompton Road – half way between the Victoria and Albert Museum and Harrod's. The Australian War Memorial in Canberra has one of the dolls, which was bought by George Long, a Buckingham Palace valet who emigrated to Australia and may have met Kitchener in his work.

A half-page article in the *Graphic* from 1916 by E.M. Evors describes the Lord Roberts workshops and how there was now a greater choice of British toys: 'Since we blotted out Bavaria from our toy maps, the home product has increased mightily.' She writes that 'mimic warriors' could buy warships from the workshops 'all capable of doing deadly works by means of clever mechanisms and comparatively innocuous projectiles'. There was also 'a motor ambulance of high popularity, with its Red Cross'. The novelty in ninepins was Verdun Skittles in which the cannon balls 'treat one helmeted German officer and eight round-hatted privates with scant reverence'. Another game was 'Trench Warfare', where the aim was to bomb enemy figures, which would then fall down to be replaced by an Allied flag. The article tells of

a veteran making such toys who had lost an arm and suggested attaching sugar tongs to the stump to hold nails; in the end, a magnet did the job. There were workshops at Colchester, Birmingham (where lead soldiers were made), Bradford, Liverpool, Edinburgh and Belfast, with the men paid a minimum of £1 a week plus their pension until they gained the skills to take them on to the trade union wage. Evors ends: 'It is worthy to note that a doll's body is turned out at Fulham in one process that at Nuremburg required eight processes'.

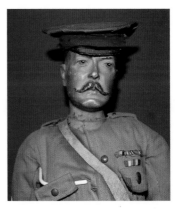

Figure 9.

Kitchener dolls were made in workshops by disabled former servicemen

The outbreak of war saw the government pass the Defence of the Realm Act (DORA). This gave the government wide-ranging powers, including the ability to requisition buildings for the war effort, create criminal offences and introduce censorship of the press. Fears of a drunken population also led to beer being watered down and pub opening times being restricted to three hours from noon and then three hours again from 6.30 in the evening.

This was very different age to live in. The working man 'knew his place'. Living conditions were poor and life expectancy was forty-six for men and fifty for women (seventy-seven and eighty-one today). One in three children under the age of five died, compared with fewer than one in a hundred today. Consumption was a big killer, with respiratory, infectious and parasitic diseases yet to be contained by antibiotics, rather than today's cancer, heart disease and stroke. One wonders just how many men were motivated to join the army in 1914 as a chance of escaping this drab existence rather than out of patriotic fervour, little knowing that the glamour of enlistment would rapidly evolve into the horrors of trench warfare.

5

The change in
women's role through the war

Another area of strife that was calmed was the fight for women's suffrage, a battle that Emmeline Pankhurst had been waging for twenty-five years. Such was her famed determination that a colour postcard at the time showed a saluting officer telling Kitchener: 'My Lord, it is reported that the Germans are going to disembark at Dover!' Kitchener, in full uniform with a quill pen in his hand and a map of the empire marked in pink on his desk, replies: 'Very Well! 'phone Mrs Pankhurst to go there with some suffragettes, and that will do!'

Pankhurst's Votes for Women campaign was put on hold and women were desperately needed in munitions factories. However, the suffragettes did not go away (Figure 10). Kitchener received a deputation of women at the War Office in January 1915, for example, demanding that restrictions beyond the DORA rules should not be imposed on soldiers' wives by commanding officers, such as not being served in hotels and public houses in the evening. Women from the landed gentry would soon find themselves working alongside working class women. By mid-1916, it was estimated that 766,000 women had replaced men in civil employment alone, and many more had taken up work in munitions factories and other occupations that the war had generated, with their voluminous initials such as FANYs, VADs, WAACs and WRNSs.

For some, there was a certain thrill to the sight of women in everyday men's jobs, as *Times* journalist Michael MacDonagh later recalled in his published diaries. He remarked that on seeing his first policewoman in her 'dowdy uniform':

Sex keeps breaking through in bright eyes, shapely ankles and ripe red lips ... a susceptible lad might well be tempted to commit an offence for the delight of being led captive – abducted, in fact – by one of these fair damsels ... The hall-porter at some of the big hotels is an Amazon in blue or mauve coat, gold-braided peaked cap and high top-boots – a gorgeous figure that fascinates me. But my favourite is the young 'conductorette' on trams and buses, in her smart jacket, short skirt to the knees and leather leggings. (Figure 11)

Some 260,000 women ultimately formed the Land Army, organised by the Board of Agriculture in 1915, doing chores such as milking cows and picking fruit. Three times as many women as were working on farms at the war's start. There was even a magazine, the *Landswoman*, to promote the movement. At the outbreak of the war, women did not have the right to vote but those aged thirty won the vote in 1918 (though it was another decade before equal voting rights with men at twenty-one came in).

Figure 10.

A worker challenges the prime minister

THE MUNITION WORKER (to Mr. Asquith): "Here are the shells - and now may I trouble you for the receipt?"

Figure 11.

Romance was in the air for *Punch* as women took up men's roles

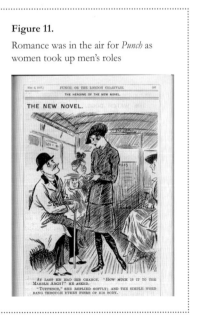

6

Kitchener

the man

Horatio Herbert Kitchener was the most famous military man of his day, well known enough to be simply referred to during his later life as 'K. of K.' – Kitchener of Khartoum – or even just 'K'. Born on 24 June 1850 in County Kerry, Ireland, he was educated in Switzerland and at the Royal Military Academy in Woolwich. In 1871, he joined the Royal Engineers. A martial strain ran in the family, a factor that the popular cartoonist Tom Browne picked up on in a comic postcard of Kitchener as a boy (Figure 12). His father had

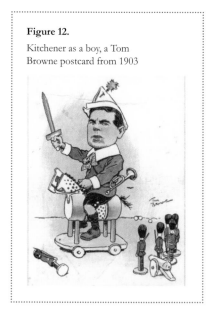

Figure 12.

Kitchener as a boy, a Tom Browne postcard from 1903

been a lieutenant colonel. Kitchener's younger brother, Frederick, fought in Afghanistan and accompanied Lord Roberts to Kabul. Frederick ran the transport columns for Kitchener's advance on Khartoum and later took part in the siege of Ladysmith. He became governor of Bermuda and was knighted, but he died in 1912. Kitchener's sister, Mrs Frances Parker, was commander-in-chief of the quasi-military Women Signallers Territorial Corps during the war.

Martyn Thatcher & Anthony Quinn

In the great entertainment venues, the music halls, such was K. of K.'s popularity that Ludwig Amann, billed as 'The Greatest Facial Artiste of the Age', and who used lightning-fast make-up changes to mimic famous faces, portrayed Kitchener along with Napoleon, Gladstone and the King. In another entertainment reference, which contrasted Kitchener's dour demeanour with the joviality of a performer, Tom Browne drew him as a music hall star, George Chirgwin, whose sentimental song 'Blind Boy' was a favourite with audiences. The stern, tall general under Browne's pen became 'Mr Bert Kitchener, the Popular White-Eyed Kaffir of the Oxford Music Hall' (Figure 13). Chirgwin, wearing a skin-tight black costume, tall hat in the style of Ally

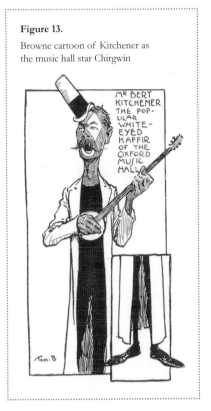

Figure 13.

Browne cartoon of Kitchener as the music hall star Chirgwin

Sloper (one of the earliest comic strip characters dating to 1884) and very long shoes, performed with a blacked-up face sporting one diamond-shaped white eye and had long been billed as 'The White-Eyed Kaffir'. He had performed as a blacked-up minstrel since the 1860s. According to the *Oxford English Dictionary*, the earliest recorded use of 'kaffir' in an African context is in reference to the Nguni peoples, often the Xhosas or (less commonly) the Zulus. Later, the term 'white kaffir' was used for white people who were too friendly with or sympathetic to black people. Kitchener would have been closely associated with this region in the minds of the public through his service in the Boer wars. At this time, kaffir would not have carried such strong offensive

Kitchener - The Man, the Poster and the Legacy

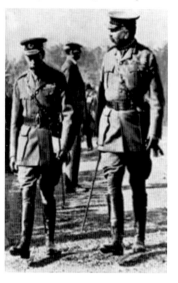

Figure 14.

Towering over the king on an inspection

connotations as it does now, with its use being legally actionable in South Africa today. So, Kitchener may have been seen as a kaffir, becoming a native black African, by learning Arabic and spending so much time in Africa.

A more straightforward comparison from Browne's cartoon was height (Figure 14). Kitchener stood a ramrod-straight six feet two inches tall at a time when the average height of an army recruit would have been five feet and five inches. Browne draws him as too tall for the page, with the legs below the knees shown in a separate frame, and the feet so large they break out of that second frame.

Kitchener's glaring, unsmiling stare was well known to the public. On one of the rare occasions he was photographed smiling and the image published as a postcard, the caption was: 'Lord Kitchener smiles' (Figure 15). His hobby was collecting Chinese porcelain and he had 'the eye of a mandarin for the rare beauties of the art of the East', according to an article in the *Sphere*. Even so, Kitchener would have been an image-maker's dream. He had height, bearing, that moustache – and cut a dash in a uniform. Even his name, beginning with what schoolchildren learn to call a 'kicking K', had a power about it, especially once he became Lord Kitchener of Kartoum – K. of K.

Kitchener was not averse to publicity. Quite the opposite. He had his portrait taken many times by the leading society photographers and paintings were made at all the key stages in his career. He was not a man who set out to be liked, but being known as a stern figure did him no harm and added to his

authority; perhaps that was a trick he learned from Victoria, a queen whose best-remembered quotation, apocryphal or not, is: 'We are not amused.'

Kitchener's military reputation was formed out in the Empire: South Africa, India and Egypt. He had served with the Royal Engineers from 1871, doing survey work in Palestine and Cyprus, before becoming military vice-consul at Erzerum in eastern Turkey in 1879. Three years later he took control of the Egyptian cavalry, became Sirdar (Commander-in-Chief of the Egyptian army) and stayed on in the region until 1898, when he was made a peer. Then followed three years in South Africa

Figure 15.

'Lord Kitchener smiles'

LORD KITCHENER SMILES.

and seven years in India as Commander-in-Chief of the Indian Army. In 1911, when he returned to Egypt as agent-general, a *Punch* cartoon by W.H. Townsend depicted him on horseback returning the stare of the Sphinx with the caption: 'Kindred spirits.' His fame was such that a street running past the cathedral in Port Said was named after Kitchener; an island in the Nile; the Indian army still occupies Kitchener House in Kolkata (Calcutta); and shortly after his death the Canadian city of Berlin changed its name to Kitchener.

To the Fleet Street newspapers and magazines, Kitchener was the hero who had crushed the Mahdist rebellion at Omdurman after the rebels had beheaded Gordon. Gordon's final moments were depicted in a heroic 1893 painting, the 'Siege of Khartoum' by George W. Joy. Kitchener was caricatured for an 1899 issue of *Vanity Fair* as simply 'Khartoum' by 'Spy' (the *nom de crayon* of Sir Leslie Ward). For a whole front-page page portrait in

the *Graphic* in 1915, he was 'A man with an iron will' and a caricature on the cover of *Drawing* magazine in February 1916 by Will Scott has him as an ocean liner.

Kitchener's exploits were widely reported internationally and many books were written about him and his campaigns, published in both Britain and the US. His arrival back in Dover from South Africa in November 1898 was marked with a full-page painting in the *London Illustrated News*, and his return to Southampton in July 1902 was front page news in the United States for Boston's *Sunday Herald,* with the headline 'A great hero is Kitchener'.

Among the books about these conflicts was *With Kitchener's Army* by Owen Watkins, an army chaplain, the frontispiece of which shows the latest in medical technology – a portable X-ray machine being use at Abadieh Hospital in the Sudan. New military technology was a feature often reported in the press, and not just for weaponry, and postcards often showed Kitchener alongside images of aircraft, dreadnoughts and giant artillery pieces.

In later years the general had a stormy relationship with journalists, but the war correspondent G.W. Steevens built the foundation for Kitchener's reputation with his Boer War reports in the *Daily Mail* and his book, *With Kitchener to Khartoum*. Yet Steevens was also aware of the faults of the man who came up with the idea of concentration camps to hold prisoners, describing him as 'more a machine than man. You feel that he ought to be patented and shown with pride at the Paris International Exhibition. British Empire: Exhibit No. 1, hors concours, the Sudan Machine.' Steevens went on: 'He would be a splendid manager of the War Office. He would be a splendid manager of anything.' Prophetic words from a book published in 1898.

Even Kitchener's most sympathetic biographers made no attempts to conceal that he was perceived as a distant, stern and sometimes ruthless figure – although they claimed that the real man was less inaccessible than he seemed. Many politicians were critical of Kitchener, especially Winston Churchill, who had served under him in the Sudan, while doubling up as a war correspondent. Henry Davray, in his book about Kitchener, which was

translated from the French in 1916, quotes a note from Churchill about the 1898 campaign to gain control of the Nile:

> The general [Kitchener] who never spared himself, cared little for others. He treated all men like machines, from the private soldier whose salutes he disdained, to the superior officers he rigidly controlled. The comrade who had served with him and under him for many years in peace and peril was flung aside incontinently as soon as he ceased to be of use. The sirdar looked only to the soldiers who could march and fight … the victories which marked the progress of the River War were accompanied by acts of barbarity not always justified even by the harsh customs of savage conflicts or the fierce and treacherous nature of the Dervish.

However, Kitchener shared his first name, Horatio, with Admiral Nelson and inspired a Nelsonian confidence among the public, despite having no experience of modern European warfare, little knowledge of the British Army at home, or the War Office – and no experience of Westminster politics. At the outbreak of war, such was Kitchener's reputation that Herbert Asquith, the prime minister, was pressed to bring in the governor of Egypt as secretary for war. Lord Northcliffe, the owner of *The Times* who had made his fortune as Alfred Harmsworth with *Answers* magazine and *Comic Cuts* and gone on to launch the *Daily Mail* (1896) and the *Daily Mirror* (1903), wanted the sixty-four-year-old Kitchener in the post – and the Northcliffe newspapers had influence. 'A harsh, ruthless, implacable soldier' he may have been, but Kitchener was also lauded as a skilful military organiser. In an editorial discussing the merits of Kitchener and Lord Haldane, chancellor, for the post as secretary of state for war, Northcliffe's *Times* of 5 August thundered:

> The eve of battle is the time for plain words. We object to the selection of Lord Haldane for the War Office because, in our belief, and in the belief of the enormous majority of his countrymen, he is not the best man available for the post. The best man in unquestionably

Kitchener - The Man, the Poster and the Legacy

Lord Kitchener, whose long and varied experience of the work of organising warfare is unequalled among British soldiers.

The Times headline on page six the next day was 'New war minister. Lord Kitchener appointed'. However, Kitchener seems not to have wanted the job and tried to return to Egypt – the prime minister, Asquith, had to call him back. On August 4, Britain had declared war on Germany without a secretary of war in place, but three weeks later the Avenger of Gordon had the job.

The Times journalist Michael MacDonagh witnessed the new war lord's first speech in the House of Lords on 25 August 1914, saying it was 'characteristic of Kitchener's aloofness and isolation' that he should come in unaccompanied and unobtrusively, only to take a place on the bench where the bishops sat. However, MacDonagh was 'taken by the shy, diffident and sunny relaxation' of Kitchener's smile when he was told he was in the wrong place. Kitchener wore glasses to read his statement, the delivery of which was 'unimpressive' and 'He appeared to be in a hurry to get the ordeal over and done with.'

It would be easy, from much of the published material on Kitchener, not to warm to him as a person and, indeed, his reputation declined towards the end of the war when he was, often wrongly, blamed for some of the inefficiencies of the war logistics. However, we must consider who was writing about him and their motivation and circumstances. He was

Figure 16.

Kitchener Toby jug by Staffordshire pottery Wilkinson. This was one of a series designed in 1915-18 by Sir Francis Carruthers Gould, regarded as the first daily newspaper political cartoonist for his work on *Pall Mall Gazette*

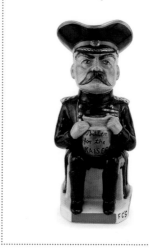

undoubtedly a stern and in some ways ruthless officer who was not close to his subordinates but that must be considered in relation to the era.

Kitchener's great – and crucial – contribution to Britain's war effort was his foresight in preparing for a long war and driving through a policy of recruiting a large army quickly – a policy that was the catalyst for the production of the many thousands of recruiting posters at the time and indirectly the contribution to poster designs to this day.

Kitchener died before his New Army was tested in the Battle of the Somme.

7

Kitchener's
wars

As an army engineer, in 1874 Lieutenant Kitchener was seconded to work as a surveyor for the Palestine Exploration Fund, a body created ten years earlier that exists to this day to study the Levant area. While there, he also demonstrated his skills as a linguist by adding Arabic to his French and German. Four years later, he was sent to map the island of Cyprus and in 1879 was appointed military vice-consul to Kastamonu, a province in Turkey. Then, he returned to Cyprus to complete his survey. Most of the next three decades was spent in Africa. Until he arrived in Egypt in 1882, Kitchener's Arabic had been 'as valueless as Patagonian' when it came to getting on in the army, according to Churchill in *The River War*. However, for the campaigns in northern Africa an officer

who could speak Arabic was indispensable. Another factor that may have aided Kitchener's promotion was his joining the Freemasons. A 2005 article in *Masonic Quarterly*, the magazine of the United Grand Lodge of England, states Kitchener 'may be considered to have been the most active to practise the craft. In an extraordinary life, his onerous military contribution to his country was intertwined with the Masonic duties he pursued on behalf of the fraternity.' It notes that Kitchener belonged to 15 lodges and chapters and served as District Grand Master of Egypt and the Sudan and of the Punjab in India. Freemasonry was well established in Egypt when Kitchener arrived in 1882, having been brought in by Napoleon's armies in the eighteenth century. Kitchener was, apparently, initiated in a lodge in Cairo the year after he arrived, at the age of thirty-three and was a freemason when he died.

Kitchener took part in the failed operation to try to relieve General Charles 'Chinese' Gordon in 1885. Gordon had tried to suppress an uprising in Sudan led by Muhammad Ahmad who claimed to be the Mahdi, the prophesied redeemer of Islam. Gordon was beheaded in Khartoum and the Mahdi died of typhus months later. Kitchener was appointed governor general of eastern Sudan. In 1888, 'Somewhat, to the astonishment of the Egyptian army, Kitchener was promoted to Sirdar (commander-in-chief)' wrote Churchill. He built a railway to ensure logistical support and used river steamers to move his army down the Nile. As commander in chief, Kitchener led the force that would take back control of the Sudan from the Mahdists, who continued to pursue the teachings of Ahmad. It took two years of fighting that led up to the Battle of Omdurman on 2 September 1898. The British went into battle with 8,000 regulars and 17,000 Sudanese and Egyptian soldiers against the 50,000-strong Dervish army of Abdullah al-Taashi, one of the leading followers of the Mahdi. The Anglo-Egyptian troops were armed with rifles and Maxim machine guns and fielded artillery. In what Kitchener himself described as 'a good dusting' 10,000 Dervishes were killed against just forty-eight lost from Kitchener's force. Among the relics recovered from the battlefield and now in the National Army Museum in London is a Persian-style

iron and brass helmet that would not have looked out of place a thousand years earlier. Churchill summed it up:

> Thus ended the battle of Omdurman – the most signal triumph ever gained by the arms of science over barbarians. Within the space of five hours, the strongest and best-armed savage army yet arrayed against a modern European power had been destroyed and dispersed, with hardly any difficulty, comparatively small risk, and insignificant loss to the victors.

Afterwards, one of the savage acts attributed to Kitchener took place, the destruction of the Mahdi's tomb and the desecration of his body's remains. Later, St John Brodrick, under-secretary of state for foreign affairs, was questioned about the desecration in the House of Commons by C.P. Scott, the *Guardian* newspaper's editor and Liberal MP for Leigh. The *Guardian* covered the exchange on 21 February 1899:

> When questioned yesterday about the treatment of the Mahdi's tomb, Mr Brodrick made no attempt to conceal the fact that the body was taken from the grave and thrown into the Nile. One would have thought it would have been a difficult thing to make this admission, but Mr Brodrick apparently considered that no apologies were necessary. It is, we believe, quite 'exceptional' for a British general to insult a dead body. These things are done by savages, but they hardly form a suitable beginning for the lessons in civilisation which we are to teach the Soudanese.

In his answer in the Commons, Brodrick had stated:

> I understand that the body of the Mahdi was taken from its grave and thrown into the Nile. It was held by the Sirdar [Kitchener] that the superstitious reverence which attached to the Mahdi's memory might cause a recrudescence of troubles in the Soudan, which, in view of the history of the past 16 years, it was necessary to take exceptional measures to avoid.

Kitchener - The Man, the Poster and the Legacy

Although the *Guardian* condemned the action, others interpreted it as revenge for the beheading of Gordon, hence another Kitchener nickname, the 'Avenger of Gordon', which was used below a full-page photograph of Kitchener in the *Sketch* on 7 September 1898, just five days after the victory at Omdurman. Magnus describes how the 'great howl of rage' in the press over the Madhi's skull being taken caused Kitchener to write to Queen Victoria expressing his regret at any distress he had caused and saying: 'I had thought of sending [the head] to the College of Surgeons where, I believe, such things are kept. It has now been buried in a Moslem cemetery.'

The Sirdar was made Baron Kitchener of Khartoum, appointed governor of Sudan and was firmly established as a national hero. After the Mahdi's defeat, K. of K. set about restoring good governance to the Sudan, improving schooling, rebuilding mosques and preventing evangelical missionaries from trying to convert Muslims to Christianity. The Mahdi's tomb was also restored.

In 1900, Kitchener was appointed Chief of Staff to the comparatively diminutive Lord Roberts – known as 'Bobs' – who led the British forces in the Second Boer War in South Africa (1899-1902). Kitchener and Roberts revitalised the flagging British military effort, though the ruthless scorched-earth measures, which included building camps to imprison civilians – concentration camps – were much criticised. Kitchener marked the end of the war with a thanksgiving service on 8 June 1902 in Pretoria. Six thousand troops attended and Kitchener presented the Royal Red Cross to eleven nursing sisters, and medals to soldiers. A Boer spy, 'Fritz' Duquesne, tried to assassinate Kitchener when he was in Cape Town, but was captured and sentenced to death. However, this was commuted when he co-operated in betraying Boer codes. He later escaped and fled to the United States. As Kitchener's reward, on his return to England in 1902, he was given the title Viscount Kitchener of Khartoum and appointed commander-in-chief in India, where he reorganised the Indian Army, merging three armies into a unified force. In 1911, he became the proconsul of Egypt, serving there and in the Sudan until 1914, when he was elevated to an earl.

8

The empire's
war lord

When offered the job of secretary of state for war at the outbreak of war, Kitchener appeared reluctant to take up the post, and his record in the job was mixed. His greatest talent lay in his organisational skills and he deployed these to great success as a colonial campaigner, but Kitchener found it difficult to delegate or work as part of a team.

Furthermore, his austere demeanour did little to advance his popularity among those who served with him. A nickname coined in South Africa, where he had broken up the regimental system of transport and supply and initially been dubbed 'K of Chaos', resurfaced because Kitchener's Army and the Territorial Army both competed for volunteers and equipment. While Kitchener's recruitment campaign was a definite success, he was seen as partly responsible for the failed attempt to capture Istanbul in a Gallipoli campaign that was driven by Winston Churchill, who was then the First Lord of the Admiralty. Furthermore, Kitchener was blamed for a shortage of high explosive shells at Ypres in May 1915.

Kitchener was no politician and fell foul of Lloyd George, who encouraged Northcliffe to turn his papers against their early favourite over the shells crisis. They became the war minister's prime critics. *The Times* headline on 14 May 1915 claimed; 'Need for shells' with subsidiary lines 'British attacks checked. Limited supply the cause'. *The Times* attack was mild, though repeated over several days, compared with the *Daily Mail* a week later: 'The shells

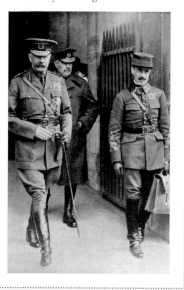

Figure 17.

Kitchener followed by Sir William Robertson leaving their hotel in Paris for the Ministry of Foreign Affairs

scandal. Lord Kitchener's tragic blunder. Our terrible casualty list.' Added pressure from other newspapers and campaigning magazines such as *John Bull* – whose editor Horatio Bottomley could fill London's Albert Hall with his lectures – led to the formation of a coalition government on 26 May 1915 in the aftermath of the Gallipoli disaster. Kitchener remained as minister for war, but as Figure 17 shows, Kitchener went to Paris with Sir William Robertson in December 1915 to thrash out their roles. As a result, it was agreed that Robertson would become chief of the Imperial General Staff responsible for presenting strategic advice to the war cabinet, while Kitchener would concentrate on recruiting for, and supplying, the army.

However, in his biography of Kitchener, Philip Magnus describes how readers turned against the newspapers because the attack on 'the nation's idol caused widespread dismay and indignation'. Copies of the *Daily Mail* were burnt outside the London Stock Exchange, subscriptions were cancelled in the gentlemen's clubs of St James's and Pall Mall, but the press attacks continued. Yet, ultimately, Northcliffe had 'underestimated ... the love and loyalty of the man in the street that Kitchener commanded' and falling newspaper sales forced the end of the press campaign. In June 1915, Kitchener's critics in the Commons attacked him for failing to foresee the need for munitions and not proposing conscription. He faced them up in a private meeting – as a lord he could not appear before MPs in their chamber – and was able to repel their attacks.

Although Kitchener had, in the words of Magnus, become a 'war-god' in the eyes of the world, this indispensable symbol of the British Empire was by now at loggerheads with his cabinet colleagues. He was no diplomat and was incapable of working as part of a political team. This may be behind the reasoning to send him on a diplomatic mission to Russia in June 1916 in an attempt to persuade the Tsar of Russia to continue fighting the Germans.

Just before his voyage, the Battle of Jutland, the biggest naval battle in history, was fought off the Danish coast with a combined total of 250 ships engaging twice over the period 31 May to 1 June 1916. Since the start

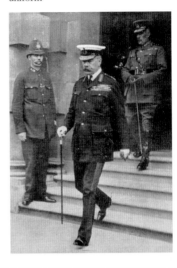

Figure 18.

Lord Kitchener on the steps of the war office in 1916. As always, note his smart uniform

of the war, the German High Seas Fleet had avoided contact with the British Grand Fleet, giving cartoonists such as Alfred Leete the opportunity to ridicule the enemy as a cowering dachshund in the face of Britain's bulldog fleet (see Figure 33 in Chapter 13). However, the stay-at-home policy allowed the British to blockade the German coast. The battle was instigated by the Germans in an attempt to tempt out and ambush part of the Royal Navy's Grand Fleet under Admiral Sir John Jellicoe, which stood at 151 ships, half as big again as the Imperial German Navy's High Seas Fleet led by Vice-Admiral Reinhard Scheer. The strategy of the two navies in terms of battleship design was very different. Admiral John Fisher was responsible for building up the British fleet before the war and he concentrated on large guns – which could hit the enemy from farther away – and speed. Germany's strategist, Admiral Tirpitz, favoured heavier armour but with smaller guns. Royal Navy ships were expected to be at sea far

Figure 19.

Kitchener follows *Iron Duke*'s Captain Dreyer on the deck of the flagship, with Admiral Jellicoe and behind him Colonel Fitzgerald, Kitchener's secretary. An hour later, Kitchener embarked on the *Hampshire*

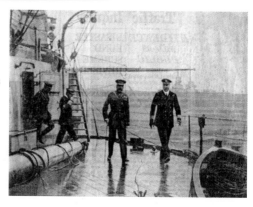

more and so needed more space for crews. In all, the British lost 6,094 men and fourteen ships, including the battlecruisers *Indefatigable, Invincible* and *Queen Mary*. Germany's High Seas Fleet lost eleven ships and 2,551 sailors. Both sides claimed victory. Although Germany could claim it inflicted greater damage, its fleet fled back to harbour with all but six of its ships damaged and stayed there for the duration of the war, handing a strategic advantage to the British. In the weeks before the battle, U-boats had laid mines and been deployed as part of the ambush strategy. One submarine, U-75, laid its mines off the Orkney Islands and, although it played no part in the Jutland battle, one of its mines was to cause a tragic sinking four days after the battle ended.

One of the cruisers that took part in the engagement was the *Hampshire*. This armoured battlecruiser had been launched in 1903 and was stationed as part of the China fleet when she was brought back to the Grand Fleet in 1914 and took part in the Battle of Jutland, although she never actually engaged the enemy. After the battle, she was ordered back to Scapa Flow, the sheltered bay that was home to the Grand Fleet, to pick up Lord Kitchener and take him on a diplomatic mission to Arkhangelsk, a vital port for supplying the Russians. Her crew had experience of the route from escorting convoys to Arkhangelsk round the northern tip of Finland and through the White Sea.

Kitchener sailed from the Scottish fishing port of Scrabster to Scapa Flow on 5 June 1916 aboard the destroyer *Oak*. He had lunch with Jellicoe on board *Iron Duke*, the flagship of the Grand Fleet (Figure 19). He then left for the *Hampshire* and set sail on his mission to Russia, with the destroyers *Unity* and *Victor* as escorts. However, as the weather turned into a Force 9 gale, the destroyers could not keep up with the *Hampshire*. Enemy submarines were not seen as a threat in such conditions, so the escorts were ordered back to Scapa Flow. Then, at about 7.30 in the evening, the *Hampshire* struck a mine laid days before by U-75, and sank west of the Orkney Islands.

9

The impact of
Kitchener's death

t was a Tuesday lunchtime on 6 June, when London's *Evening News* came out with the headline: 'Lord Kitchener drowned.' Kitchener had sailed for Russia aboard the *Hampshire*, but the ship had gone down. Although the official line was that the battlecruiser had been struck by a torpedo or a floating mine, by the evening, rumours were circulating that the news was a ruse to mislead the Germans. However, Kitchener's body was never found and stories continued to spread about his death and the mission.

The front page of the *Daily Mirror* the next day was a 'Lord Kitchener Memorial Number' with a head-and-shoulders portrait of the 'great field-marshal' taking up almost the whole front page. In the United States, the *New York Times* on

the same day ran the sinking on its front page with a photograph of Kitchener. The main headline read: 'Kitchener and staff perish at sea; lost on cruiser, perhaps torpedoed; England suspects spies of the deed.' Among the dozen subsidiary lines were: 'Intern aliens, British cry, London newspapers sure Germans knew of war chief's plans and sunk the *Hampshire*,' and 'Northcliffe papers, once earl's opponents, join in the chorus of praise.'

It was a similar story in many other countries, with, for example, the French paper *Le Petit Journal* running a full front-page colour photograph to mark Kitchener's death (Figure 20).

There were uncorroborated reports of locals on Orkney being prevented by troops from trying to rescue survivors who reached the rocky, gale-wracked coast of the island and ultimately, just a dozen from more than six hundred and fifty officers and men on board lived through the ordeal.

In a *Financial Times Magazine* article in 2014, Jeremy Paxman describes the situation at the time:

The conspiracy theories began almost at once. How could such an important figure, in the full protection of the greatest navy in the world, be dead? On June 7, the *Evening News* reported that all over London people believed the sinking had been the work of German secret agents. On hearing the shocking news of Kitchener's death, members of the stock market cried out, 'This is the work of spies! Shall we any longer tolerate German-born members in our midst?' Establishment figures like Admiral Jellicoe and First Lord of the Admiralty Arthur Balfour – to say nothing of absurd bigots like the founder of the nationalist rag *John Bull*, Horatio Bottomley – were inundated with letters alleging the disaster had been the work of German fifth columnists, Bolshevik infiltrators or Irish nationalist saboteurs. Sometimes – as when an officer was said to have been spotted going into K's cabin and proffering him a service revolver, to enable him to do the decent thing – it was claimed that the disaster had been perpetrated by the British government.

Figure 20.

Kitchener's death reported in the *Le Petit Journal*, 25 June 1916

Figure 21.

How Bernard Partridge marked the loss of Kitchener in *Punch*

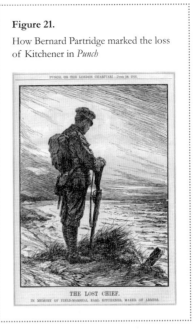

Then there were theories that Kitchener wasn't dead at all. Why, since his sister had been unable to make contact with him through a medium, he must be alive! He was in Russia, commanding the tsar's army. He had been spotted living in a cave in Orkney. Like King Arthur, K. of K. would one day return when his country needed him most.

Messages from foreign governments paid tribute to 'one of Britain's most famous sons ... one of the most striking figures of our age'; 'the Great Reformer of the glorious English Army'; and 'the brilliant organiser of the mighty British Army'. The King and Queen attended a memorial service at St Paul's Cathedral along with the prime minister and four thousand mourners. *The Sphere* devoted seven pages to the service. Leading cartoonist Bernard Partridge marked the loss of Kitchener in *Punch* (Figure 21). Recruitment advertising chief Sir Hedley Le Bas was appointed to run a national memorial fund with the proceeds going to disabled officers and men. Le Bas also edited the *Lord Kitchener Memorial Book*,

which included Kitchener's speeches, along with portraits, cartoons and illustrations, and the signatures of the great and good. The memorial issue of the *Sphere* summarised a *Daily News* article that described Kitchener as a soldier:

> His methods were patient and laborious rather than swift and empirical. He was not seen at his best on the field of battle or in handling a sudden situation, but in laying his plans for an assured though undramatic end. He realised the magnitude of the war at the beginning with more certainty perhaps than anyone else. Wherever his judgment was brought to bear on the crucial operations of the war it was rarely at fault. It was on his survey of the theatre of war in Gallipoli that the decision to evacuate was taken ... his decision rescued us from an impossible situation and saved the army of Gallipoli.

Thousands of memorial postcards and mementoes were produced. Kitchener's passing inspired the poet Anita Dudley to produce a book of sonnets to him. Her introduction talks of 'hero worship' and how the news she heard at the Caledonian Market in North London 'came like a thief in the night, whispered from stall to stall by white-faced girls'. She saw how the silence that descended on the raucous market became an 'eloquent tribute' and gave the poet 'her first insight into the heart of the great loving people'. Stall-holders wept, women sobbed aloud and tears rolled down sailors' cheeks before the crowd broke out singing 'Rule Britannia' and 'God Save the King'.

Theories and conspiracy theories about Kitchener's death rumbled on. In a strange twist, in October 1925 the journalist Frank Power (whose real name was Arthur Vectis Freeman) began a series of articles in the *Referee*, a Sunday newspaper, questioning events on board the *Hampshire* at the time Kitchener died. He continued his claims for a number of weeks and the reaction of the public to his claims forced an enquiry by the government, which, apparently, interviewed many people about their recollection of events. The information collected was published a year later. Power then changed his line,

claiming Kitchener's body had been found in Norway. He went there with a film crew and a few weeks later a coffin arrived at Waterloo station in London, where Power went to meet it. At this stage, the authorities intervened and in August 1926 the coffin was opened in the presence of the police and Sir Bernard Spilsbury, the forensic scientist who had helped convict the murderer Dr Crippen. The coffin was empty, and it was later shown that Power had engaged in an elaborate hoax. The *Referee* disowned Power, who was interviewed several times by the police, but not prosecuted.

In another twist, 'Fritz' Duquesne, the Boer spy who had tried to assassinate Kitchener during the Second Boer War, added to the sabotage rumours. He had turned to spying for the Germans and sabotage of British shipping in South America. In a 1932 book, *The Man Who Killed Kitchener* by Clement Wood, Duquesne claimed to have been on board the *Hampshire* disguised as a Russian duke and had guided a U-boat to sink the cruiser. Those claims have been discredited, but he moved to the United States and was caught running the biggest spy ring in the country's history during the Second World War.

The conspiracy theories did not go away, however. For a 1934 *Pictorial Weekly* article built around Power's claims, the loss of K. of K. was 'the greatest mystery of the age – or the greatest fraud' (Figure 22). The article was more sympathetic to Power than many commentators, possibly because the writer, Hayden Church, had met the 'small, stoop-shouldered' Power several times and describes how Sir Arthur George, former private secretary to Kitchener, was convinced of Power's honesty. Ultimately, though, the events were inexplicable for Church. They were still explicable almost fifty years later for the French magazine *Histoire* in 1981, with its cover feature 'Kitchener: un mort mystérieuse.' And that was still the situation for Jeremy Paxman in 2014. The former BBC *Newsnight* presenter was the face of the broadcaster's coverage of the centenary of the start of the Great War, even stepping into Kitchener's shoes for a version of Leete's *London Opinion* cover for the *Radio Times*. Later in the year, he wrote about 'The strange death of Lord Kitchener' in the *FT Magazine*. The article began: 'The British war secretary's demise at sea in June

Figure 22.

For *Pictorial Weekly*, Kitchener's loss was still 'the greatest mystery of the age' in 1934

1916 has spawned endless conspiracy theories. A century on, can the speculation be laid to rest?'

Paxman summarises the machinations that have surrounded Kitchener's death but the novelty of his article lay in the contents of files Paxman had sought out from government archives with a Freedom of Information order. Unfortunately, the result is: 'The files are as dull as ditch water.'

Arguments about Kitchener's reputation rumbled on for years and he was criticised by Lord Esher in *The Tragedy of Lord Kitchener*, the essence of the biography being that Kitchener had been called upon to do work for which he was not fit and that 'the armour of his soul had rusted'. This prompted Asquith, the former prime minister who had appointed Kitchener, to leap to his defence in two substantial articles in *Pearson's* magazine to set out 'the incalculable services which Lord Kitchener rendered to his country in the Great War' and deny Esher's claims. The second article also reproduced a pivotal letter that Kitchener had written to Asquith before the shells crisis, in which he wrote that Field Marshal John French, who commanded the British Expeditionary Force, had told him his troops had as much ammunition as they would need.

10

The Liverpool Pals –
an example of how Kitchener's recruits fared

On 7 August 1914 Kitchener made his appeal for 100,000 recruits. Local campaigns to raise battalions of men sprang up around the country. One such was in Liverpool, where Lord Derby enlisted the local press on 24 August to promote what he called 'pals battalions'. He addressed a packed meeting with the words:

> This should be a battalion of pals, a battalion in which friends from the same office will fight shoulder to shoulder for the honour of Britain and the credit of Liverpool.

Within days, more than a thousand men had been recruited, at such a rate that recruitment was temporarily halted. Many of these men will have been fans of Liverpool Football Club and stood on the Anfield ground's terrace, which was named after the battle of Spion Kop where the British army had suffered a heavy defeat at the hands of the Boer forces in 1900. As part of the King's (Liverpool) Regiment, which dated back to 1685, these Pals would normally have worn as a cap badge the White Horse of Hanover, but George V approved the 'Eagle and Child badge', Lord Derby's Stanley family crest, in recognition of the recruiting campaign. Liverpool formed four battalions, each of a thousand men, many of them workmates from the same district. A shortage of equipment meant training with just one old rifle

Figure 23.

Liverpool men volunteering to serve in the Pals battalions

for every ten men, who were billeted in makeshift camps in local parks and Derby's own estate.

By the end of September, more than fifty towns and cities had formed Pals battalions. Derby's reward was to be appointed director of recruiting. *Punch* marked the success of the appointment a year later in a full-page cartoon by 'Craven Hill' (Leonard Raven-Hill): Derby is shown as a recruiting sergeant at the head of a stream of men coming from hills and factories far and near.

After a year's training, the Liverpool battalions left for France. On 1 July 1916, they faced action on the Somme and some of the heaviest losses ever suffered by the British army. Almost twenty thousand men were killed in a day and twice as many wounded. The Liverpool Pals took the village of Montauban from the Germans, one of the few successes, but two hundred of them were killed. Days later, the same division lost five hundred men – 'Liverpool's blackest day'. Divisions from other parts of the country took even worse losses: of 720 Accrington Pals, 584 were killed, wounded or missing; the Leeds Pals lost 750 out of 900; and other battalions lost half of their men. The Liverpool Pals went on to fight at Arras, Ypres and Passchendaele.

Once conscription was introduced in 1916, no more Pals battalions were recruited and most were amalgamated into other battalions. Some of the Liverpool Pals were sent to train US troops; others went to Russia. In total, almost three thousand Liverpool Pals were killed during the Great War.

It is difficult to judge what the troops thought of Kitchener. However, the number of mementos crafted by them that refer to Kitchener does suggest that he was revered by many. One example is a slate shove ha'penny board that was sold on eBay in March 2015. Scratched on the back is a rendering of Leete's image with the 'Your country needs you' wording. It is signed 'PTE Wills Aldershot Thiepval 1916.' Thiepval is a village in Picardy that was at the centre of the Somme battlefront. It is the site of the largest British war memorial, designed by Sir Edwin Lutyens, that stands 43 metres (140ft) high. The Memorial to the Missing of the Somme is inscribed with the names of 72,195 missing British and South African men, who died on the battlefield and who have no known grave.

11

Posters

in a consumer society

Posters belong to a body of fleeting ephemera. Produced by advertising agencies, government departments, companies and individuals, they are circulated en masse. As Martin Hardie, keeper of prints and drawings at the Victoria and Albert Museum between 1921 and 1935, has noted: 'In its brief existence a poster is battered by the rain and faded by the sun, then pasted over by another message more urgent still.' But the idea of the poster has an ancient history. The walls of Pompeii, the Roman city buried by ash from Vesuvius almost two thousand years ago, are covered to this day with painted messages and advertisements.

Kitchener - The Man, the Poster and the Legacy

Bills announcing theatrical events and official statements were stuck to the posts that marked pedestrian routes down London's streets before the Great Fire of 1666, hence the terms 'billposters' and 'billstickers'.

Large typographic posters had become common on the walls of European cities by the seventeenth century, and with the invention of lithography around 1790, it became much cheaper to reproduce a graphic image on paper. As in Pompeii, the typographical announcements of the Georgian and early Victorian eras were simply pasted up on any suitable surface (hopefully, covering the offerings of a competitor!). Charles Dickens was one of the first people to use the word 'poster' in print, in *Nicholas Nickleby*, which was published in monthly parts in 1838 and 1839. This world of fly-posting was reined in from the 1860s with the appearance of special sites to rent for posters – billposting stations or hoardings. Hoardings, which were erected around the many building sites of the time, were rented by billposters from the site owners. This innovation was promoted by the Bill-Posters' Association founded in 1861 and the *Billposter*, a trade magazine. It was the start of 'bill posting' becoming 'outdoor advertising'.

Dickens did not live to see the advent of the people's picture gallery that decorated the streets in the late Victorian era. In the days of *Nicholas Nickleby*, colour printing would have been achieved by several wood blocks, but chromolithography, originating from the mid 1800s, brought colour printing into the machine age and large posters became common on Victorian streets. Printers and advertisers co-operated to standardise sizes and outdoor displays. The advertising industry itself expanded from the establishment of R.F. White and Son in 1800, with advertising copywriter Eric Field reckoning that '*The Times*' had on its books nearly one hundred advertising agents' by 1895.

The paths of advertising and art crossed continuously in this period. Artists influenced advertising, which – being so widespread – affected their work in return. In the mid-1800s, art shook off tradition and went out into the street, creating advertising through commission and, occasionally, unwittingly. The most famous example of the unwilling advertising illustrator is provided by the painting 'Bubbles' by the Pre-Raphaelite painter John Everett Millais. Large

colour prints of this were first distributed with the Christmas 1887 issue of *Illustrated London News*. Later, with the addition of a bar of soap, it was turned into an advertisement for A&F Pears (which can be seen in the Lady Lever Gallery, Port Sunlight village), a landmark use that helped earn managing director Thomas Barrett a reputation as 'the father of modern advertising'.

The birth of the British graphical poster is dated to 1871, with a dramatic woodcut by the painter and illustrator Fred Walker for a stage version of the Wilkie Collins' sensational mystery novel *The Woman in White*. His dramatic image of the Anne Catherick character, swathed in a cloak and seen full length from behind, is considered the first modern pictorial poster. Walker died at the age of just thirty-five, but his work anticipates similar designs of the 1890s and he believed that posters could become 'a most important branch of art'. In fact, he is often credited with having started the fashion for artistic advertising in Britain.

Martin Hardie, in his introduction to the catalogue for a 1931 exhibition of international posters at the Victoria and Albert Museum in London, identified several stages in the development of the poster. The French were next to take on the mantle from Walker, through Jules Chéret establishing the *affiche artistique* (artistic poster) in the 1870s, followed by Henri de Toulouse-Lautrec, Pierre Bonnard and Edouard Vuillard through to the 1890s. Back in Britain, William Nicholson and James Pryde – working together under the name 'J.&W. Beggarstaff' – brought in a Japanese influence with a definite pattern and restricted, simplified colour. And the work of Aubrey Beardsley 'bore the touch of genius', so that by the end of the century, posters were not only a mature marketing tool, but were collected and recognised as an artistic medium. In 1894–96, two exhibitions of posters were held in London's Royal Aquarium and magazines devoted to poster art were published in the UK, United States and France, with titles promoting the medium such as *The Studio*, *The Yellow Book* and *The Poster* all launched in the years 1898–1900.

In the Edwardian era, the expansion of travel by rail, the London Underground, sea and air provided the wherewithal for the transport poster,

such as John Hassall's 'Skegness is So Bracing' of 1908. By 1912, such was the ubiquity of posters that Pablo Picasso was inspired to paint 'Paysage aux affiches' – 'Landscape with posters' (Figure 24). Leading up to the war, publicity manager Frank Pick was instrumental in driving visual quality on London's Underground system. The Victoria and Albert Museum has described how, once war began, 'he refused to hang the [government's recruiting] posters in his stations because of their poor design.' Instead, he commissioned Frank Brangwyn and Gerald Spencer Pryse to draw up recruiting posters.

The US-born artist Edward McKnight Kauffer, who worked in France and Germany before coming to London at the start of the war, produced well over a hundred designs for London Transport, starting in 1915 when Pick commissioned him to do four landscape posters, including 'Oxhey Wood' and 'In Watford' promoting travel to the Hertfordshire towns at the end of the District line. His painterly style at this stage suggests the influences of both Van Gogh and also of Japanese colour woodcuts, and he later developed an abstract feel. Hardie, in his book *War Posters Issued by Belligerent and Neutral Nations 1914-1919,* makes the point that British posters were generally of a far better technical quality than those on the Continent and that in lettering, 'the British poster is still supreme'.

Figure 24.

The painting 'Paysage aux affiches' by Pablo Picasso depicts a world over-run with posters and advertising (1912)

Martyn Thatcher & Anthony Quinn

Around 1915 and 1916 in Germany, a group of artists were on their way to launching a protest group against the militarism they saw enveloping the nation. Their manifesto was supposedly inspired by an advertisement for Dada, a hair tonic, and so Dadaism was born. Another version of events is that one of them thrust a knife into a dictionary that stabbed the French word *dada*, meaning 'hobby-horse'. The group was rebelling against the bourgeois values of the time and giving vent to their despair over the futility of war. They had no unifying artistic style, but worked in collage, photomontage and with found objects, rather than traditional forms such as painting and sculpture.

It follows that by 1914, with the breadth of artistic styles and a vibrant commercial marketplace in magazines, advertising and graphic design, the poster was ready for a propaganda role in time of war. Before the Great War it would have been easy to differentiate between a commercial advert and a government one, but during the war it became rapidly less so. Commercial advertising even started to mirror government advertising in the design and wording of posters. At first, many officials objected to the use of posters in war advertising and the deployment of official information. However, mass-produced, full colour, large-format posters could be considered an innovation of warfare, the medium of the war poster epitomising the modernity of the conflict. War posters constituted a political adaptation of a medium that had already pervaded European cityscapes.

Figure 25.

Advert for Dada hair tonic

Kitchener - The Man, the Poster and the Legacy

Recruiting posters were designed to place emotional pressure on people based on cultural traditions, such as the family, sentimentalism or the military hero, by developing a representation of national identities, identities on which the waging of war hinged. Without the consent and material support of the Home Front, combatant nations would never be able to sustain the huge losses that a long-term war of attrition entailed.

A body called the Parliamentary Recruiting Committee (PRC) was set up at the start of the war to oversee military recruitment and was chaired by Herbert Asquith, the prime minister, and it provided some of the most powerful images of British society during the Great War. The vivid recruiting posters of the period have come to be regarded as vital to the mobilisation of popular support for the war. However, one of the designs for a recruiting poster, Alfred Leete's Kitchener 'Wants You', has become an icon that endures right into the twenty-first century. However, his design was initially produced privately after appearing on the *London Opinion* cover of 5 September 1914. As with others privately produced, it does not seem to have reflected the attitudes of government, but rather those of a new breed of commercial advertisers and graphic designers whose involvement in the recruiting campaign may have been resented by those in power. The rapid growth of a national market for cheap branded goods had brought these advertising experts into prominence and now they were bringing their influence into the realm of politics.

Another change the war and its propaganda posters brought about was in the way people imagined masculinity and femininity. Initially, war disrupted men's lives by mobilising them into the armed forces, and, in some cases, wounding and killing them. Women's lives, too, changed by their being forced to consider different kinds of labour and at the end of the war they won the vote. But these changes need to be understood in relation to changes in how men and women perceived their own genders – having a male or female body meant something different in 1918 than it had five years earlier. The presence of wounded veterans made it very difficult to ignore how vulnerable male bodies were in an age of industrial war.

As the war progressed, women had been given labouring jobs and, literally, clothed in new uniforms; consequently, they viewed themselves as different compared with their mothers' generation in supposedly traditional female roles. Posters were used to introduce and reinforce such changes by conveying information about how men and women could and should contribute to an all-encompassing global war. Images of men and women in uniform mixed with old-fashioned ideals helped forge mental alliances between individuals and the nation as a whole. Posters provided society with a new visual vocabulary for picturing men and women in relation to each other, the nation and machines.

The academic Meg Albrinck has emphasised the importance of masculinity in British recruitment posters and how this depiction evolved. As an example, it was strongly suggested that a man would suffer social embarrassment and personal guilt if he did not serve in the armed forces. In the same issue of *London Opinion* that carried Leete's Kitchener cover, the illustrator had a half-page cartoon showing a newly enlisted soldier with a girl on each arm, while a gad-about young man can only look on jealously (Figure 26). The idea that being a soldier would make a man more attractive to the opposite sex and altogether more 'manly' was adopted and adapted by the poster makers. It may be considered that British poster makers projected an ideal masculine behaviour, attempting, and maybe succeeding, in manipulating popular attitudes of masculine duty.

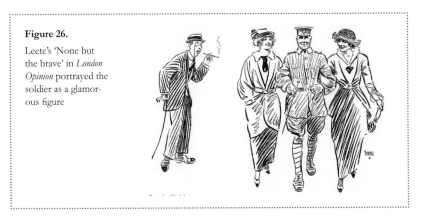

Figure 26.

Leete's 'None but the brave' in *London Opinion* portrayed the soldier as a glamorous figure

Kitchener - The Man, the Poster and the Legacy

After the end of the Great War, Leete, having served in the conflict, produced several recruiting posters. Gone is any hectoring, and rich colours replace the muted tones of the Kitchener image. The description of one of his posters at the Imperial War Museum, 'See the World and Get Paid for Doing It' (Figure 27), shows how different is his imagining:

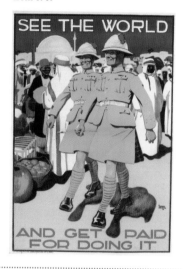

Figure 27.

'See the World and Get Paid for Doing It', an Alfred Leete recruiting poster from 1919

> The image occupies the whole, with the title integrated and positioned across the top edge, in white outlined black. The text is integrated and positioned across the bottom edge, in red. All held within a green and blue border. Two British infantrymen walk through a crowded Near Eastern bazaar, both in khaki uniform including a kilt and 'sola topee' helmet. One smokes a cigarette, the other a pipe. Behind them, crowds of local people trade goods. In the background, domes and minarets are outlined against a deep blue sky.

Another Leete poster also promotes the benefits of joining up: 'Become a Motor Engineer and See the World. Join the Tank Corps. Smart Men Wanted for Armoured Car Companies.' A third poster, published by the Tank Corps, takes up a similar theme: 'Wanted. Smart Men for the Tank Corps. Let Professor Tank Teach You a Trade.'

Leete's view of the world has evolved and his later ideas have contributed to attitudes to war recruitment today. However, the rich trove of images in the Great War posters raises a question – why, in the Second World War, were

similar images generally absent from official poster art or indeed from broader imaginings of war? Although the Australian army used a poster of Churchill replicating Leete's Kitchener pose and wording, and the United States reused its Great War recruiting images for various purposes in the later conflict, the British authorities did not. For the British, humour and skill acquisition were the order of the day and this continues even now. Of course, there was no voluntary campaign in the Second World War with all men (and latterly, women) called up from the start. The exception that proves the rule came in the 1990s when the army resurrected the iconic Leete image for a campaign that aimed to attract more ethnic officers. In the posters, Kitchener's face appeared to have been, literally, torn out of Leete's 'Your Country Needs You' artwork and replaced by that of black and Asian officers.

Picasso may have noticed the impact of poster campaigns on the urban environment, but an aspect of posters that is often overlooked is their effect *en masse*. At least since the Victorian era, hoardings often covered lengths of wall or even the sides of buildings. While it was often a case of billposters fighting for space or plastering over rivals' advertising, the repetition of a single image over many sites or in a single place can produce an effect that is greater than the sum of its parts. In many locations, posters juxtaposed or pasted on top of each other in blocks created an unplanned, but nevertheless powerful, effect. Some of the descriptions of the Kitchener posters hint at this. In his 1988 book, *Kitchener's Army*, Peter Simkins states:

> *The Times* recorded the scene in London on 3 January 1915; 'Posters appealing to recruits are to be seen on every hoarding, in most windows, in omnibuses, tramcars and commercial vans. The great base of Nelson's Column is covered with them. Their number and variety are remarkable. Everywhere Lord Kitchener sternly points a monstrously big finger, exclaiming 'I Want You'.

Half a century later, the magazine and advertising illustrator Andy Warhol ran with the idea to great effect in his artwork.

Kitchener - The Man, the Poster and the Legacy

It has been suggested that poster images help us see aspects of disenchantment with the twentieth century – a retreat from representations of war and warriors into more complex and compromised images. Consider also what images of Auschwitz and Hiroshima did to representations of war, and the work of photojournalists such as Don McCullin in magazines and Sunday newspaper supplements in the 1960s. What association was WikiLeaks founder Julian Assange trying to spark in the minds of viewers when he held a 2010 press conference with a massive blow-up of 'Shell-Shocked Marine', a 1968 Vietnam War photograph by McCullin, behind him?

Recent generations are left with a shifting landscape of imaginings of war: some heroic, others negative, troubled, unresolved, unsettled. The moral conundrum of how to imagine war without glorifying it is with us still. Recruitment into the armed services today is based on images of travel, camaraderie, peace-keeping and skill achievements rather than the 'bullying techniques' and sentimentality of the Great War.

12

Popular
cartoonists of the day

he advent of the magazine *Punch* in 1841 sparked a booming market for cartoonists and illustrators in Britain. Indeed, the term 'cartoon' in its modern-day sense of a humorous drawing was coined by the humorous weekly in 1843. Before then, a cartoon was a preparatory sketch for an oil painting of the same size, or for

a tapestry, mosaic or stained glass window. In the next sixty years, dozens of other titles were launched, many of them with illustration and cartoons at their core. *Cornhill, Illustrated London News*, the *Strand, John Bull, Vanity Fair*, the *Graphic,* the *Sketch, Tatler, Bystander* and their like helped establish and sustain the careers of many artists and illustrators. Photography was in its infancy and it was not until the advent of the half-tone process in the mid-1880s that magazines were able to start experimenting with printing photographs.

Among the artists who made a living from illustrating magazines such as *Cornhill* were the Pre-Raphaelites. But they also appreciated the power and influence of magazines and set out their agenda as artists and poets by launching their own publication, the *Germ* in 1850. *Punch*, meanwhile, had established an unrivalled roster of artists on its staff, such as John Leech, Richard Doyle, John Tenniel and Charles Keene.

It was Tenniel who drew the political cartoon 'Dropping the Pilot' for *Punch* in 1890 that is mimicked to this day and sums up a pivotal event in European history. German emperor Kaiser Wilhelm II had been crowned two years before and watches from the deck as chancellor Otto von Bismarck walks down a staircase at the side of the ship. Bismarck was seen as having helped preserve peace in Europe and the bombastic Kaiser set the country on a more bellicose course. Figure 28 is a cartoon in *Bystander* that echoed the Tenniel image a month after the outbreak of war. Bismarck is striding through water to reach Wilhelm, whose boat has foundered on rocks.

Figure 28.

Bystander cartoon of 1914 harks back to a 20 year-old *Punch* cartoon by John Tenniel

Kitchener - The Man, the Poster and the Legacy

Some Victorian and Edwardian illustrators are still household names – W. Heath Robinson with his world of unlikely machines and the fairies of Arthur Rackham, for example – and the images of many others are familiar even if their names have lost their renown. Supporting them were private art schools, many of them founded by illustrators, such as that of John 'Skegness is So Bracing' Hassall. Other famed illustrators who live on include Sidney Paget, whose depictions of Arthur Conan Doyle's Sherlock Holmes in the *Strand* influence depictions of the character in print and on screen to this day. The name of Kate Greenaway, a Victorian illustrator, is on an annual medal for the best children's books. Her work, which appeared in many magazines, including *Illustrated London News* covers, was not only popular among readers but also changed the way the Victorians dressed their children. The cute toddlers of Mabel Lucie Attwell's pictures in magazines, from the classy *Tatler*

Figure 29.
Bruce Bairnsfather's first 'Old Bill' cartoon drawn 'under somewhat difficult circumstances'

to a cheap women's weekly such as *Home Notes* were the basis of a range of pottery that was still being made into the 1960s. Attwell also produced a cartoon strip called 'Wot a Life' for *London Opinion* during the Second World War.

It was only in the final quarter of the twentieth century that it became fast and cheap to reproduce colour photographs in print. Furthermore, until then, the print quality of letterpress halftones – the main printing technique for newspapers and topical magazines – was poor, so it was easier to portray events using sketches. Because of this, some of the most popular illustrators gained superstar

64

status and readers knew them by name. This was certainly the case at the time of the Great War and although photography gained in popularity, the drawn image was still widespread in the Second World War.

The work of Bruce Bairnsfather was inspired by life in the trenches and made him a household name. His best-known character is Old Bill, whose exploits, along with his pals Bert and Alf, were a weekly feature in the *Bystander* from his first submission in 1915, when he was serving at the Front with the 1st Royal Warwickshire Regiment (Figure 29). 'I have drawn it,' he wrote 'as well as I can under somewhat difficult circumstances, and, I may say, from first-hand impressions.' Bairnsfather was injured during the Second Battle of Ypres. Back in Blighty, as the troops called home, he developed his humorous series featuring Old Bill, a curmudgeonly veteran soldier with trademark walrus moustache and balaclava. The best remembered of these shows Bill with another trooper in a muddy shell hole with shells whizzing all around. The other trooper is grumbling and Bill advises: 'Well, if you knows of a better 'ole go to it.' The drawings were later collated in a series of eight books entitled *Fragments from France*, which sold over a million copies with editions published in the US, Canada and Australia. The *Oxford English Dictionary* cites the term 'Old Bill' being used for an army veteran in the 1920s and 1930s; the fact that many of these men went into the police force, often sporting moustaches such as that depicted on the comic character, is one of the theories behind the police being nicknamed the Old Bill even now.

The title *Better 'Ole* was used for a musical and two films based on the strip in both Britain and the US. Bairnsfather went on to write books and plays, and in 1927 directed a film. He appeared on the stage in London and New York, was one of the first celebrities to be recorded talking on film in the US, and then took part in early television broadcasts from Alexandra Palace. He contributed to *Life*, the *New Yorker* and *Judge* in the United States as well as British magazines. Old Bill was resurrected in the Second World War, being published in several magazines and becoming a mascot for the US forces in Britain. Bairnsfather introduced Old Bill's son, Young Bill, and a film was

made about them, *Old Bill & Son,* in 1941. An omnibus that had taken troops to the Western Front was decorated in Old Bill livery after the war and has been exhibited in the Imperial War Museum in London.

Another cartoonist who fought in the war was Cyril Bird, who was injured at Gallipoli in 1915. He adopted the pen name Fougasse, after a type of land mine, and began contributing to *Punch* in 1916, with the cartoon 'War's brutalising influence' (Figure 30), as well as the *Graphic* and *Tatler*. He became art editor of *Punch* from 1937 to 1949, then editor until 1953. During the Second World War he designed many government posters, including the 'Careless Talk Costs Lives' series. In 2009, British Airways began using one of his cartoons for its first class menus, continuing an association that goes back to the 1930s, when Fougasse penned advertising posters for BA's forerunner, Imperial Airways.

William Barribal was already an accomplished painter and designer at the turn of the twentieth century who used his wife as his principal model to create images of exquisite and fashionable Edwardian women. He drew

Figure 30.
Cyril Bird's first *Punch* cartoon. He took his pen name, Fougasse, from a type of land mine

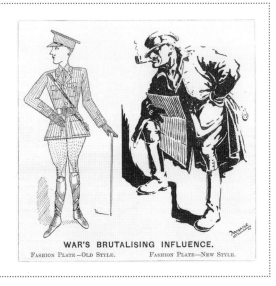

WAR'S BRUTALISING INFLUENCE.
Fashion Plate—Old Style. Fashion Plate—New Style.

several Great War recruitment posters and worked for various magazines, including *Vogue* and *Pearson's*, as well as producing railway posters and playing cards, these works being keenly sought after today.

Another veteran illustrator was Bert Thomas who worked as a freelance for the *Strand, Pick-Me-Up* and *Ally Sloper's Half Holiday*. In 1905, he began an association with *Punch* that led to the magazine publishing more than a thousand of his cartoons. Four years later, he began supplying *London Opinion* with political and social cartoons. However, his most famous offering was produced in the early months of the Great War, when he drew – supposedly in ten minutes – a grinning Tommy lighting a pipe with the caption 'Arf a Mo', Kaiser!' which was published in Northcliffe's *Weekly Dispatch* in 1914 and helped raise £250,000 to send tobacco to the troops (Figure 31). In 1916, Thomas enlisted in the Artists' Rifles and later served as a war artist for the National Savings campaign.

Figure 31.

Bert Thomas's smoking Tommy

In 1918, he drew the largest poster for an appeal to invest in War Bonds – it covered the facade of the National Gallery in London's Trafalgar Square. Painted in oils, it was seventy-five feet long and showed Drake facing the Spanish Armada. Thomas produced similar posters in Cardiff and Glasgow, and in 1918 was awarded an MBE for his contributions to the war effort. Many of his wartime cartoons, along with those of Wilton Williams, were published as a book by *London Opinion* after the war.

George Studdy contributed to many magazines around the turn of the century, with much of his work based on the portrayal of

anthropomorphised animals. In 1921, he invented Bonzo the dog for the *Sketch*. The puppy was a 1920s craze and appeared in many compilation books and advertisements, selling everything from tobacco, cars, soap and polish to confectionery and pickles. He was also used for one of the first neon signs put up in London's Piccadilly Circus.

Animals also made the name of Lawson Wood, who was employed by Arthur Pearson from 1896 and went on to gain popular acclaim for his depictions of stone-age humans and dinosaurs. The art instructor Percy V. Bradshaw employed him to work on the *Art of the Illustrator*, a collection of twenty portfolios demonstrating six stages of a single painting or drawing by twenty artists. During the Great War, Wood served in the Kite Balloon Wing of the Royal Flying Corps. His work spotting planes from a hot-air balloon led to Wood being decorated by the French.

Many illustrators were members of the London Sketch Club, which traces its history back to a meeting in 1823 and the formation of the Artists' Society in 1830. Its members included *Punch* artists Sir John Tenniel and Charles Keene, and the book illustrator Arthur Rackham. The London Sketch Club has noted that 1914 saw the 'collapse of the illustrated book market' as prices jumped because of paper scarcity, and that 1939 led to a similar loss of work for magazine illustrators as photographs replaced drawings for both editorial and advertising, and hand-drawn lettering for headlines lost favour to typesetting.

In the middle of the nineteenth century, Britain had come under threat of invasion from the French under Napoleon III. In response, many people volunteered for military service and in 1859 a group of painters, sculptors, engravers, musicians, architects and actors formed the 38th Middlesex (Artists') Rifle Volunteers. Its first commanding officers included the painter Henry Wyndham Phillips and Fredrick Leighton, later president of the Royal Academy. A battalion of the London Regiment, its cap badge showed the Roman gods Mars and Minerva, symbolising the joining together of art and war.

Many of the Pre-Raphaelites signed up for the Artists' Rifles, including John Everett Millais, Holman Hunt and William Morris. *Punch* cartoonist John Leech

was another member. The battalion served in both the Second Boer War and the Great War, with recruits such as sculptor Charles Sergeant Jagger, Bert 'Arf a Mo' Kaiser' Thomas, the poets Wilfred Owen and Edward Thomas, Harold Earnshaw (illustrator and husband of Mabel Lucie Attwell), and the painters Paul Nash and John Nash. Eight members of the battalion were awarded the Victoria Cross during the Great War.

It was in this tradition that Alfred Leete worked.

13

Alfred Leete
the Kitchener poster artist

Alfred Leete was the son of a farmer and born in Northampton on 28 August 1882 (Figure 32). The family moved to Weston-super-Mare and he left school at the age of twelve to be an office boy for a surveyor in Bristol. This was followed by jobs as a draughtsman in a furniture company and as a lithographer. In 1898, at the age of 16, Leete had his first cartoon accepted by the *Daily Graphic*. In 1905, *Punch* accepted one of his drawings. He then became a full-time illustrator and as well as drawing cartoons, found success designing posters and as a commercial artist. His drawings appeared in many magazines, including the *Pall Mall Gazette*, the *Bystander*, *London Opinion* and the *Sketch*.

Leete drew the Lord Kitchener 'Your country needs you' image for the 5 September 1914 cover of the weekly magazine *London Opinion*. The previous month, he had designed a frontispiece, 'Get out and get under', for

Figure 32.

Alfred Leete, aged about 34, larking about in civilian clothes with comrades from the Artists' Rifles

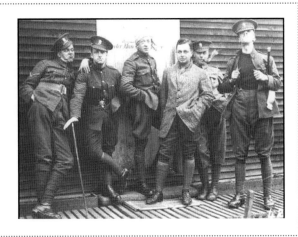

Figure 33.

Leete portrayed a dachshund-led German fleet as cowardly in *Bystander* (26 August 1915)

"GET OUT AND GET UNDER"

the *Bystander* which depicted the German fleet cowering in a kennel with a dachshund because the Royal Navy, led by a bulldog, was approaching on the horizon (Figure 33). The short-legged, long-bodied 'sausage' dogs were an easy target not just for their Teutonic associations but because they were a favourite of Kaiser Wilhelm. In 1901, he had built a memorial in the grounds of Wilhelmshöhe Castle near Kassel, which he used as a summer retreat, after his dachshund Erdmann died. The veteran *Punch* cartoonist Lewis Baumer also portrayed a dachshund as a 'social pariah'. As a result of such associations, the breed declined

Figure 34.

A Schmidt the Spy book brought together Alfred Leete's cartoons from *London Opinion*

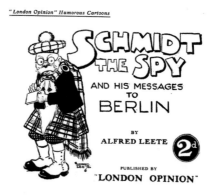

in popularity as patriotic dog lovers expressed their allegiance through their choice of pet.

Leete provided the illustrations for several books including *All the Rumours* and the *Bosch Book* in 1916. His popular 'Schmidt the Spy' strip for *London Opinion* drew on the 'spy fever' at the time, with Carl Hans Lody, a German naval reservist, shot in the Tower of London as a spy on 5 November 1914. The character was turned into a silent film in April 1916 with the actor Lewis Sydney playing Schmidt, an inept German infiltrator.

Such was Schmidt's fame that Leete was able to use the character after the war (24 August 1919), this time in *Bystander*, to represent Germany (Figure 35).

After the war Leete produced a series for the *Sketch* called 'Masbadges', of fantastical creatures made up by combining animal mascots with the badges of their regiment. These included a leek-nosed goat of the Welsh Guards; a surly-looking bulldog with the insignia of the Royal Artillery for its nose; and the Royal Flying Corps Bird, which looks like a penguin, the beak being formed by the wings of the corps' badge.

Leete went on to produce advertising posters for many products and companies, including Bovril, Connolly Leather, Lever Brothers, Rowntree's

Kitchener - The Man, the Poster and the Legacy

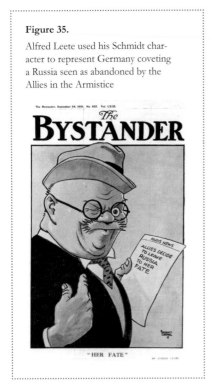

Figure 35.

Alfred Leete used his Schmidt character to represent Germany coveting a Russia seen as abandoned by the Allies in the Armistice

Chocolate and the brewer William Younger as well as producing striking posters for the London Underground. His 'Mr York of York, Yorks' character became the star of the first British animated film commercial with synchronised sound, for Rowntree's Chocolate.

An advertisement for *London Opinion* in the *Daily Mail* of 18 February 1922 described Leete as 'the funniest man in the world'. He provided the covers and illustrations for the Mrs Bindle stories by Herbert Jenkins in *Pearson's*. His Bovril slogans were used as the basis of a national competition in 1928 and published as the *Bovril Slogan Cartoon Book*. Leete, described in his obituary as a 'black and white artist and cartoonist' died at home in Pembroke Square, London, after a seizure on 17 June 1933. His signature, alongside those of Bert Thomas and John Hassall were still reported by the *Daily Mail* as being a feature of Sandy's Autograph Bar near Piccadilly Circus in 1939.

Some commentators have described Leete solely as an 'illustrator' and not a 'graphic designer', which implies that the design elements of the Kitchener poster might not have been initiated by him. However, it takes only an observation of his paintings and other poster work, particularly those he produced for London Underground, to show the extent of his design, as well as artistic, skills. His paintings from the trenches, as a member of the Artists' Rifles,

Figure 36.

Leete's 'Sanctuary or
the Ever Open Door'
(1917)

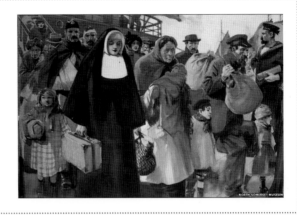

reveal an artist capable of producing fine work, including the 'Sanctuary, or
The Ever Open Door' – a haunting painting of Belgian refugees (Figure 36).

14

London Opinion
magazine

T he weekly magazine *London Opinion* was owned by C. Arthur
Pearson, a publishing company named after its founder
who had established *Pearson's Weekly*, one of the best-selling
Victorian magazines, in 1890. This was a great success from
the start, and the proceeds enabled Pearson to establish many magazines and
in 1900 to launch the *Daily Express*, sparking a commercial battle with the

rival *Daily Mail* that would continue through the century. However, Pearson himself had begun to go blind and from about 1910 sold his newspapers and magazines. The *Daily Express* ended up in the hands of Sir Max Aitken, later Lord Beaverbrook, and the magazine interests, including *London Opinion*, went to a rival magazine publishing company, George Newnes. Pearson then devoted his time to promoting scouting, the National Institution for the Blind and the St Dunstan's Home for soldiers blinded in the Great War.

London Opinion was founded in 1903 and 'conducted' by A. Moreton Mandeville. Four years later, it ran limerick competitions that led to so many entries that questions were asked in parliament about the great demand for postal orders to pay for the entries. The magazine also sponsored the Laughter Show, an international exhibition of humorous art, at Holland Park Hall (11 May to 6 June 1914). Circulation figures are difficult to establish with any certainty at this time, but it was probably selling a quarter of a million copies a week. *London Opinion* continued as a weekly until the November 1939 issue at the outbreak of the Second World War, when it cut its page size, adopted more colour and went monthly, mimicking the format of *Men Only*, which had been launched in 1935 as a general interest monthly for men. Although the November issue makes reference to the magazine's role in supporting the troops in the Great War, no mention is made of the Leete cover or poster.

London Opinion was the first national title to recognise the talent of twenty-year-old *Cambridge Evening News* cartoonist Ronald Searle by publishing one of his cartoons in 1940. For the historian of comics Denis Gifford, it 'was probably the funniest magazine of its era'. Norman Thelwell, today best known for his cartoons of girls and their dimwitted ponies, also had his first break on *London Opinion*, as did *Billy Liar* creator and *Daily Mirror* columnist Keith Waterhouse. It was one of the magazines considered to have such popular appeal that it was distributed as recreational reading matter to the fleet during the war. However, *London Opinion* was ultimately owned by the same company as *Men Only*, and was folded into that title in 1954 as the market for general interest men's magazines contracted.

15

The Government's
recruiting campaign

At the start of the war, many people expected it to be over by Christmas. Even a year later, *Bystander* ran a competition over several issues with a £50 prize, to guess how the war would end by plotting a map of where and when the Allied forces would be positioned when hostilities ceased. The editors cannot have imagined that the war would last another three years. However, Lord Kitchener, the newly appointed secretary of state for war, saw things differently. He expected a long war, so he set out to mobilise the whole nation with the biggest recruitment campaign the world had seen. In the process of raising an army of volunteers, he changed the nature of propaganda.

Historically, the British advertising industry had a long-term goal of controlling full-scale political campaigns. Advertising experts were confident that they could teach the public about politics 'in the same way they taught them about Colman's mustard'. Industry experts proposed similar tactics to central government and in 1913 the War Office was urged to adopt 'modern' methods to sell the idea of joining the ranks of the army. Before the war, British advertisers had made an effort to modernise the political process, but they encountered resistance from those who believed that modern advertising had no part to play in the democratic process – the 'brash commercialism' of advertising seems to have been anathema to both politicians and civil servants.

On 6 August 1914, parliament agreed an increase in army strength of half a million men and initiated the Paliamentary Recruiting Commitee. This

body was to oversee all official recruitment to meet the targets. The first task in raising 'Kitchener's army' was to call for 100,000 volunteers, aged between nineteen and thirty, at least five foot three inches tall and with a chest size greater than 34 inches. The PRC started its poster campaign, but the ground had already been laid with advertising, and there may have been many willing recruits including men from the many semi-militarised patriot groups that had been established, such as the Scouts.

In his book, *Advertising*, Eric Field relates how the idea of the government advertising for recruits dated back to a discussion during a game of golf on a Wednesday in October 1913. Playing that day were Colonel John Seeley, the secretary of state for war; Hedley Le Bas, who had founded the Caxton Publishing Company in 1899 and ran an advertising arm to promote his books; and Sir George Riddell, proprietor of the *News of the World* and a director of Caxton. The discussion resulted in a ground-breaking £6,000 budget to produce 'real advertising instead of the stilted [classified] advertisements which the government had used for a hundred years or more'. The campaign ran over the winter and used whole pages in the popular dailies, including a *Daily Mail* front page at £350. That whole front page, headed 'What the Army offers', is described by Field as 'the first real advertisement ever used by the government' when it appeared on 15 January 1914 (Figure 37).

The campaign was judged a success, with an accompanying booklet exhausting its 50,000 print run within a week and resulting in an extra

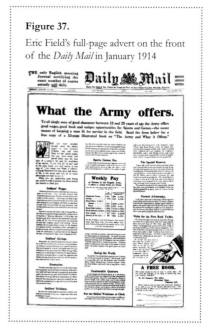

Figure 37.

Eric Field's full-page advert on the front of the *Daily Mail* in January 1914

4,000 men signing up. So, the War Office authorised another campaign for the autumn and winter of 1914 and expanded the budget to £20,000. Of course, that plan was never carried out. For, in July 1914, a call came through to Field from Colonel Richard Strachey, the assistant adjutant general for recruiting, who 'swore me to secrecy, told me that war was imminent and that the moment it broke out we should have to start advertising at once'. Field drafted an initial advert headed: 'Your King and Country need you' below the royal coat of arms. It first appeared in newspapers on 5 August 1914, at a size eight inches deep across two of the seven columns at the top of page three in the *Daily Mail* as well as other daily newspapers. It sought men aged between eighteen and thirty. Adverts that ran a week later had changed the terms to 'a period of three years or until the war is concluded. Age of enlistment between nineteen and thirty.' The copy ended with 'God save the King' at Kitchener's insistence, as did many of the early posters. None of these press advertisements was illustrated, apart from the royal crest, and they were managed separately from the PRC's later poster campaigns.

Twenty-four days after the initial call to arms in the newspapers, the government ran a new advertisement in the press, again with the royal crest. This time, the headline words were 'Your King and Country need you' and the following text of 'Another 100,000 men wanted.' Later adverts altered the style, with the *Daily Mail* of 7 April 1915 showing a map of Britain with the headline 'If the German Army were in Cardiff' and pointing out that Ostend was as near to London as the Welsh capital. It ended with the slogan, 'Your Country Needs You Now.' In 1916, voluntary recruitment was superseded by compulsion and adverts were aimed at specialists, as in 1917 when adverts appealed for 'men who understand horses'. For his work on the campaign, Le Bas was appointed to run the government's advertising propaganda and was knighted in 1916.

William Allen in his book on the history of the printing firm David Allen & Sons, which printed many of the PRC's posters from its plant in Harrow, north London, states that the government's poster campaign was sparked by

a privately produced recruiting poster of September 1914 for the London Underground by Frank Brangwyn. The idea caught on slowly, with small, letterpress exhortations, but blossomed in 1915 when the pictorial poster came into its own. He quotes the *Billposter* magazine that 'Such an illustration of poster power has been given as no country and no age ever saw before.'

To mark Trafalgar Day, 21 October 1914, a hoarding was erected around the base of Nelson's Column in Trafalgar Square. The *Daily Mail* reported record crowds for the annual celebration with 'many French and Belgian people in the throng'. Of course, the Battle of Trafalgar in 1805 was against the gallant foes of the French fleet, whereas now Britain was going to war to defend France. A wreath laid at the base of the pillar in tribute to the French sailors who fell more than a century earlier described them as 'compatriots of our comrades in arms today'. Marie de Pereot wrote a letter to the *Daily Mail*:

> Never in history has an allied country been more lavish with its resources and men than is Great Britain at the present moment; her heroic sons are shedding their blood for my country; my people welcome 'Tommy' as a brother.

Pictures in the French weekly *L'Illustration* show crowds milling around a massive poster with a royal crest on either side of King George V's morale-boosting words: 'We are fighting for a worthy purpose and we shall not lay down our arms until that purpose has been achieved.' Another side of the hoarding quoted the famous naval signal hoisted by Nelson at the start of the battle: 'England expects that every man this day will do his duty.'

Times journalist Michael MacDonagh recalls seeing his first recruiting poster on 6 August 1914 and cites several examples in his diaries, which were published twenty years later. It was his writing that Simkins quotes in Chapter 11 as MacDonagh describes London in wartime, with the streets still thronged, but the clocks stopped, church bells silenced and Kitchener pointing his 'monstrously big finger'. In a similar vein, Fleet Street journalist Edgar Wallace wrote a six-issue illustrated part work for George Newnes, *Kitchener's*

Army and the Territorial Forces, in 1915. It refers to 'recruiting literature flooding' London and how difficult it was to avoid it:

> You could not get away from it. It was flashed upon the screens of picture theatres; it appeared on some of the boards before the theatre doors; it was on the tram tickets; it was pasted on the windows of private houses; it appeared unexpectedly in the pulpit and on the stage; it was printed in neat little characters upon leaflets; it sprawled largely upon the gigantic posters with which private enterprise covered whole fascias – Your King and Country Need You.

Newnes turned the six parts into a book with the same title under Wallace's name. It was very popular and other publishers also took the work up, including a publisher called Combridge, with the title *In the King's Army: from Citizen to Soldier*, and J. Askew with *At Kitchener's Call: Britain's New Armies*.

The first poster that the PRC designed carried only text: 'England Expects Every Man to do His Duty' (Figure 38). Most of these early re-cruiting posters were just enlarged versions of handbills, usually with text in one or two colours. Often, the wording simply consisted of the technical terms of enlistment. The first pictorial poster, numbered as PRC 11, was in late October 1914, by which time one million men had already volunteered. After Germany overran Belgium, many posters made

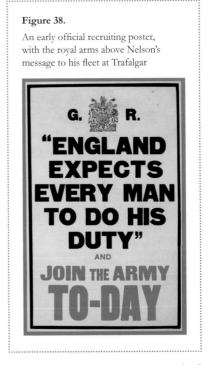

Figure 38.

An early official recruiting poster, with the royal arms above Nelson's message to his fleet at Trafalgar

reference to the way Britain's treaty with Belgium, which guaranteed her neutrality and was also signed by Germany, had been described as a 'scrap of paper' by the German chancellor – and the brutality of the 'Hun'. Posters printed during the occupation show German tactics in Belgium. Hardie refers to two 1914 posters, held by the Imperial War Museum (IWM): one threatens to kill a third of the male inhabitants should the German troops be fired upon; another states that the authorities had ordered the massacre or burning alive of three hundred people. While atrocities, of course, did take place, we must remember these were propaganda posters designed to incite hatred.

One theme to be repeated many times is that of the 'Remember Belgium', issued initially as an official poster in November 1914 as PRC 16 (Figure 39). In the centre of the poster stands a fighting man in khaki, his rifle resting on the ground, his eyes looking towards the viewer. Behind him to the left, a fire destroys a village and sends black smoke billowing across the sky. To the right, a woman flees with an infant and a toddler. While she looks back over her shoulder, the toddler looks forward and reaches a small hand towards the man in khaki. At the bottom of the poster appears the command 'Enlist To-day.' The poster invites the viewer to consider the alleged immorality of the German armies and to take up arms against them. Two structural devices are employed to imply that enlistment is a moral option for defeating barbarity. First, fighting is depicted as a humanitarian act – as helping women and children – so disguising the brutality in which the soldier will have to participate. Framing battle in this way, the image

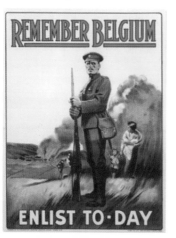

Figure 39.

'Remember Belgium'

depicts the government's appeal through the outstretched hand of the child, covering national interests with personal ones. Second, the positioning of the soldier, standing between the fire and the fleeing family, suggests that enlistment will directly protect women and children. Just as the soldier in the poster stands between the family and the fire raging behind them, so the viewer will be able to stand between other innocents and German barbarism. Some 140,000 copies of this poster were distributed.

The PRC avoided more explicit reference to the many atrocity stories, choosing against depicting scenes of a gruesome character and focusing in a more uplifting way on the character of the men who served. However, the public will have been well aware of German 'atrocities' from the press. A perceived atrocity closer to home is exploited in the poster shown in Figure 40, 'Remember Scarborough.' This is a reference to the bombardment of that seaside town, along with Hartlepool and Whitby, by German warships on 16 December 1914. The attack killed 137 people and left almost six hundred wounded, most of them civilians. A graphical version of the poster was produced for the PRC by Lucy Kemp-Welch, an artist renowned for her horse paintings, and her book jacket for Anna Sewell's *Black Beauty*.

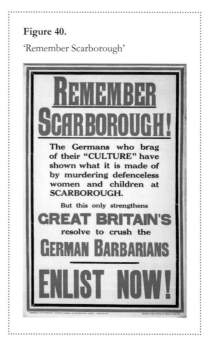

Figure 40.

'Remember Scarborough'

Another example was the October 1915 execution of 49-year-old British nurse Edith Cavell, which was portrayed in a *London Opinion* cartoon as 'Britons. Avenge!' with a bugler standing over the prone body of the nurse

and sounding his call. The caption ran: 'The brutal murder of Nurse Cavell by the Germans sent a thrill of horror through the civilised world.' Cavell was matron of a training school for nurses in Brussels and stayed on after the city fell in the first few weeks of the war. She cared for wounded soldiers irrespective of nationality and was arrested after being accused of spying and helping Allied soldiers escape to Holland. Cavell admitted to the charges and was sentenced to death. Diplomatic efforts to persuade the authorities to commute the sentence were rejected and she was executed by firing squad. As well as journalists running the story, a propaganda campaign publicised the incident and the Essex recruitment committee produced a poster of a photograph of Cavell with the text: 'Murdered by the Huns. Enlist in the 99th and help stop such atrocities.' Cavell herself was reported as saying as she awaited her fate: 'Patriotism is not enough. I must have no hatred or bitterness for anyone.' She was hailed as a heroine and martyr with a statue just off Trafalgar Square in London and the Cavell Nurses' Trust that helps nurses in time of need was set up in her name in 1917.

Over time, the PRC's campaign became more sophisticated and manipulative, moving away from relying on a call to duty. Instead, other elements came in, such as: appeals to a man's desire for adventure and camaraderie; by demonising Germans; and by subjecting the men not in uniform to public reproach. Many cartoons ridiculed men who did not sign up. And pressure was applied across society. Such was the demand to conform that the 'War Comments' column in *Bystander* referred to readers' letters criticising the fact that a man shown as part of the title on the cover of the magazine was not in uniform (16 September 1914). The next week, the title was replaced by two soldiers scanning the horizon from a fortified gun emplacement. The magazine also dubbed itself 'the illustrated war review'. The title artwork had already been changed from the peacetime version showing a seated man reading *Bystander* and bracketed by two women, to the man and women looking out with binoculars over the coast with smoke in the distance. Below, the devil was shown throwing dice (26 August 1914). The covers changed again in

1915, portraying the man back at home with the women, but in uniform with his arm in a sling – a 'Blighty wound' in the jargon of the day.

Posters appeared proclaiming 'You're proud of your pals in the Army of course! But what will your pals think of you? – Think it over!' And 'Do you feel happy as you walk along the streets and see other men wearing the King's uniform?', the implication being that a 'real' man would be ashamed to face his peers in anything but khaki. Men who did not enlist were rejecting a tradition of supportive masculine camaraderie in the army, ignoring the needs of comrades and damaging their own masculinity. A 1915 recruiting poster by Frank Brangwyn makes it clear: 'Your friends need you – Be a man.' A direct implication is that refusing to volunteer rendered you neither a good friend, nor a man. Words such as 'Why are you stopping here when your pals are out there?' and 'Think! Are you content for him to fight for you? Won't you do your bit?' were blunt statements, as were: 'Come into the ranks and fight for your King and Country – Don't stay in the crowd and stare' and 'It is far better to face the bullets than to be killed at home by a bomb.' These posters used few colours, emphasising the text only and carry a message that would have been more powerful in 1914 than today. By the middle of 1915 the campaign was abrupt in its approach, declaring in the text-only PRC 103: 'There are three types of men. Those who hear the call and obey. Those who delay. And – the others. To which do you belong?'

Posters that tried to provoke guilt in the general populace were later considered to be invidious. The poster 'Daddy, what did you do in the Great War?' by the illustrator Savile Lumley features a middle-aged man in silent repose in his postwar armchair – likely overcome with shame – as his son plays with toy soldiers on the floor. His daughter, resting on his knee and reading an account of the war, asks, in all innocence, the damning question. The idea has been credited to a printer, Arthur Gunn, who is reported to have imagined himself as the father in question. After seeing a sketch of the scene by Lumley, Gunn joined the Westminster Volunteers.

Guilt was also used in posters that urged women to persuade their men-folk to enlist (Figures 41 and 42), by both questioning their men's masculinity and

Figure 41.

Women of Britain say 'Go!' (PRC 75)

Figure 42.

'Send a man to join the army today'

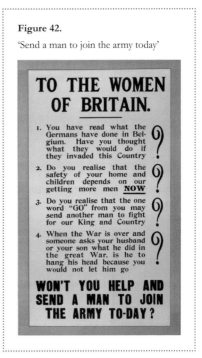

TO THE WOMEN OF BRITAIN.

1. You have read what the Germans have done in Belgium. Have you thought what they would do if they invaded this Country **?**

2. Do you realise that the safety of your home and children depends on our getting more men **NOW ?**

3. Do you realise that the one word "GO" from you may send another man to fight for our King and Country **?**

4. When the War is over and someone asks your husband or your son what he did in the great War, is he to hang his head because you would not let him go **?**

WON'T YOU HELP AND SEND A MAN TO JOIN THE ARMY TO-DAY?

questioning the patriotism of women who hesitated to give up their husbands, fathers and sons to the service of the nation, as in 'Women of Britain, Won't you help and send a man to join the army to-day?'

The editorial line in most newspapers and magazines from the start portrayed a patriotic image of the man in uniform and this approach was taken up in government posters and advertising. In the very issue of *London Opinion* that first carried Leete's Kitchener cover, the artist portrayed a man in uniform with a woman on each arm while a wimp in the background looks on (see Figure 26 on page 59). Peace protests were reported but usually in negative terms and men who tried to avoid signing up were the butt of jokes in both words and cartoons. However, within weeks the press was complaining through both articles and cartoons about heavy-handed censorship by the government and blamed

this for hindering recruitment because there was no news to report. A *Bystander* cartoon, 'What damps recruiting ardour' shows the censor as a grumpy old woman pouring water over potential recruits from a balcony above the entrance to a recruiting office. The caption quotes the novelist and journalist Arnold Bennett writing in the *Daily News* about the paucity of information available to the press: 'The British War Office gave [only] eight lines in seven days concerning the deeds of what is admittedly one of the very finest armies known to modern history. And then it is alarmed because recruiting has fallen off.'

The *Daily Telegraph's* 1955 centenary magazine stated that Kitchener had written to the lords lieutenant of counties and the chairmen of the Territorial Force Associations on 10 August 1914 seeking their support. The next day, the weekly average of 500 recruits coming forward had jumped sharply: 'Now the number to enlist daily is as much as 3,000.' The 30 September 1914 issue of *Bystander* ran photographs of the king reviewing 'Kitchener's own' at Aldershot. That month, the prime minister said that 'recruiting is going on so fast ... whether we should not dampen it down'. Simkins refers to the problems of finding accommodation for the new recruits and coping with the 'flood' of men. Height standards were raised and the PRC was asked to restore the previous level of enlistment. He states that 12,527 men were enlisted on 11 September, but that the daily average fell to about half that the following week.

The PRC continued to issue pictorial posters until September 1915 by which time the trend of recruiting was steadily downwards. Later, based on evidence gained from recruits, the authorities decided that the most effective designs were not those that bullied potential recruits but rather those that projected 'a delightful geniality'. One example of such geniality was Bert Thomas's 'Arf a mo' Kaiser' from the *Weekly Dispatch* (see Figure 31 on page 67).

Within seven months of the start of the advertising campaign, three million posters had been issued at a cost of £7,750. But after this bonanza, life became difficult for billposters. The main reason was the shortage of materials. Supplies of Swedish pulp for paper-making began to fall off because of a lack of British coal exports. The Swedish mills produced mechanical pulp

– made from crushing trees – and chemical pulp, made from boiling trees, hence the need for coal to boil the wood. The latter process produced the much better paper, which was used for posters and the better magazines and books. Newsprint, on the other hand, was three-quarters mechanical pulp and the rest chemical – that is why is goes brown and falls apart relatively quickly. Also, artificial inks made from coal-tar dyes produced in Germany were no longer available so lithographers had no artificial blues and reds. They had to go back to using inorganic dyes such as vermilion, chrome, umber, ochre, ultramarine and bronze-blue, and the price of these increased.

The PRC's poster campaign was enormous. According to its records, the main recruiting drive involved producing more than 140 poster designs, from which no fewer than 5.7 million full-sized posters were printed plus half a million smaller strip posters for use on taxi cabs, trams and railway carriages. Most of the PRC designs were issued in single sheet, double crown size (30 by 20 inches) rather than the larger eight-sheet (80 by 60 inches), sixteen or thirty-two sheet size favoured by commercial advertisers. This campaign ran for little more than a year to the end of 1915, generating an average of three new designs a week. It was much larger than any previous public-ity campaign run by the government. The PRC's poster campaign was not designed to create enthusiasm for the war but to sustain it. Kitchener initially asked for 100,000 recruits and within weeks almost 300,000 men had come forward in an unprecedented show of patriotism. He sought 300,000 more in May 1915 (Figure 43).

Figure 43.

Reproduction of a Kitchener letter appealing for recruits (1915)

Martyn Thatcher & Anthony Quinn

By April 1915, official recruiting posters were largely indistinguishable from contemporary advertisements and poster designers freely mixed official imagery with the consumer advertising they continued to produce. The PRC even converted a tobacco advertisement into a poster (PRC 63) with the acknowledgment 'Reproduced by kind permission of Messrs. Abdulla & Co. Ltd.' The advert in question was by Frank Dadd, who had worked for several magazines as a black and white artist and figure illustrator, but most notably for the *Graphic* for thirty-four years until 1910. His patriotic images included one during the Second Boer War of a soldier being seen off on a transport ship by his wife and young son to illustrate the words of Rudyard Kipling: 'He's an absent-minded beggar, but he heard his country's call.' (The words were also set to music by Arthur Sullivan and published by the *Daily Mail* as a way to raise funds for the dependants of soldiers fighting in the Boer War.) Dadd's commercial work for advertisers, particularly Abdulla tobacco during the Great War when he was sixty-five, gave him the opportunity to work in colour. The Abdulla adverts showed Boer War veterans praising young soldiers, with phrases such as 'My boys, I am proud of you' and 'Good bye, my lad, I only wish I were young enough to go with you!' It was the latter that was adopted as a poster.

For some politicians, such tactics smacked too much of commercialism. Simkins writes that the Scottish miners' leader Robert Smillie was reported as stating that 'a method which might have been unexceptional for calling attention to the virtues of a shop, a soap, a circus or a pill, seemed inappropriate in the case of a great nation struggling at the crisis of its fate'. By June 1915, public resentment had started to creep in, and the campaign was described as 'bullying by poster'. Smillie's response to the poster 'Daddy, what did you do in the Great War' was, supposedly 'I tried to stop the bloody thing my child!'

Frederick Scott Oliver, a prominent political writer and businessman at the opposite end of the political spectrum, took a similar view in his 1916 book, *Ordeal by Battle*:

There is also a further question: did the country, reading these various advertisements and placards, heroic, melodramatic, pathetic and facetious,

form a true conception of the gravity of the position? Was it not in many cases confused and perplexed by the nature of the appeal? Did not many people conclude, that things could not really be so very serious, if those in authority resorted to such flamboyant and sensational methods, methods so conspicuously lacking in dignity, so inconsistent with all previous ideas of the majesty of Government in times of national peril?

The method itself, no doubt, was only unfamiliar in so far as it used the king's name. It was familiar and common enough in other connotations.

The introduction of conscription in early 1916 meant the need for government's recruiting poster campaign was greatly reduced and the PRC's propaganda role was merged into the Parliamentary War Savings Committee. However, a need developed for workers on the Home Front, resulting in posters such as 'Hold up the flag of freedom', which was issued by the Ministry of Munitions in 1917 (Figure 44). Posters continued to be used – but conscription resulted in a shortage of (male) billposters. Women soon took their place, although 'they needed courage, especially the first pioneers, to face the male ribaldry to which the public nature of their work inevitably exposed them' when pasting up bills made up of up to thirty-two sheets – about ten feet by thirteen feet – from a ladder. In 1917, the maximum size of posters was reduced under paper restriction orders and imports reduced to half the total of the previous year. The government took over the Harrow factory of David Allen & Co.

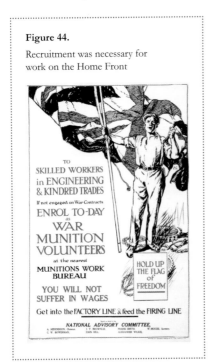

Figure 44.

Recruitment was necessary for work on the Home Front

The Stationery Office had printed three million posters and officials were adding to this total at the rate of 600,000 a month. This created tremendous problems logistically and in July production was suspended with a million posters remaining in store. Many tonnes of these were then sent overseas and by the end of September, with declining recruitment, the pictorial poster campaign was suspended.

For all the volume and variety of posters, the mediocrity of most designs when judged on artistic merit alone has been commented on. In *War Posters*, Hardie reviewed the best examples on both sides and noted that the Imperial War Museum had collected twenty thousand examples and the Victoria and Albert Museum several hundred from all nations. The book focuses on artistic merit and condemns most of the British effort:

> The earliest days of the war saw available spaces everywhere covered with posters cheap in sentiment, and conveying childish and vulgar appeals to a patriotism already stirred far beyond the conception of the artists who designed them or the authorities responsible for their distribution.

For Hardie:

> We had much to learn from the concentrated power, the force of design, the economy of means, which made German posters sing out from a wall like a defiant blare of trumpets ... the posters of Germany have a force and character that make most of our own seem insipid and tame.

In particular, the PRC 'possessed a poor degree of artistic perception, and, added to this, a very low notion of the mentality of the British public'. He does go on to admit that the PRC efforts improved in 1915, with examples from Bernard Partridge, Guy Lipscombe, Doris Hatt, Walter Caffyn and Leonard Ravenhill. He has a special mention for Gerald Spencer Pryse, who

Kitchener - The Man, the Poster and the Legacy

was in Belgium when war broke out and saw the fighting and the refugees before he was himself injured. As a despatch-rider, he carried lithographic stones with him and made his drawings directly on them, not on paper. The outstanding figure for Hardie, both in quantity and technical accomplishment, was Frank Brangwyn. However, he notes that:

> Among the best and most efficient [posters] may be mentioned Alfred Leete's 'Kitchener'. But if one compares Leete's head of Kitchener, 'Your Country Needs You', with Louis Oppenheim's 'Hindenburg', the latter, with its rugged force and reserve of colour, stands as an example of the direction in which Germany tends to beat us in poster art.'

There is no mention of *London Opinion*, or that Leete's image was designed to be printed on newsprint by letterpress, which reproduced tones very poorly, whereas Oppenheim's image was for a war loan poster as a colour lithograph in 1917. The text on the German poster is a quote written in Hindenburg's own hand, demonstrating its importance and hence the likelihood that a substantial amount of time and effort was spent on its production. The use of such a comparison suggests that Hardie, possibly Britain's foremost expert on poster art, was unaware that Leete's image had been knocked off at short notice for a magazine cover in the urgency of the outbreak of war.

Figure 45.

Some of the thousands of different recruiting posters produced, both official and commercial

Maurice Rickards, the graphic designer and ephemera encyclopaedist, puts the blame for the poor visual quality of many recruiting posters at the door of civil servants commissioning printers to do the work: '[The] result was a remorseless flow of pernickety coloured drawings from printers' "art departments".' He quotes the printer Arthur Gunn claiming the ideas for forty-three designs: 'I used to conceive an idea for recruiting, get a sketch made myself by our own artist ... and take it round to 11 Downing Street. If they liked it, no one else could stop it.' Although Rickards also champions the artistry of Brangwyn and Pryse, Savile Lumley's 'Daddy, what did you do in the Great War' is more widely remembered than any of these.

16
The Kitchener
poster

Once newspapers such as *The Times* and *Daily Mail* carried Eric Field's advertisement at the outbreak of war with its call to arms, 'Your King and Country need you. Will you answer your country's call?' The message was clear, only the image of Lord Kitchener's face was missing. They came together on the cover of the 5 September 1914 issue of *London Opinion*, with a dramatic rendition of Kitchener peering above his pointing finger with the words 'Your country needs YOU', an obvious reference to words of the newspaper advertising campaign (Figure 46). This cover image was designed by Alfred Leete and owed little either to the War Office or to the Parliamentary Recruiting

Figure 46.

Alfred Leete's 'Kitchener' cover for *London Opinion* (5 September 1914)

Figure 47.

London Opinion was not the only private sector recruiter. This *Punch* poster was based on a September 1914 page cartoon

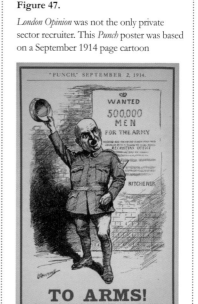

Committee. Leete was a professional cartoonist and the approach he used ran counter to the official tradition of recruiting in the name of the king and at a time when the PRC was still only using typographical posters. Kitchener initially refused to have himself used by the recruiters and there is no record that he authorised the use of this image by Leete, who would in any case have been unlikely to even think of seeking permission. The raison d'être of cartoonists and their magazines was to poke fun at political figures.

Posters using the magazine cover artwork were issued during September and October 1914. The first used Leete's artwork and wording and was a wholly private venture by the magazine's publishers. The second was printed by David Allen with the words 'BRITONS [Kitchener] wants YOU' credited to Eric Field and the Caxton advertising agency. It was not uncommon

for companies, particularly newspapers and magazines, to fund their own posters in a national cause. In its issue of 2 September 1914, *Punch* had its eponymous inspiration portrayed as a recruiting sergeant (Figure 47). James Eno, the manufacturer of Eno's Fruit Salt, had already purchased a painting by Frank Dadd called 'Follow the Drum' and had transformed that into a recruiting poster.

A parallel came from Lord Northcliffe's *Weekly Dispatch*, which in November 1914 had carried a photo-montage of a wounded soldier on the battlefield with an inset of a football crowd and the caption 'Will They Never Come?' Northcliffe's Associated Newspapers reproduced this design as a recruiting poster (Figure 48), and issued it free to cinemas in the form of a lantern slide, leading the War Office to congratulate Northcliffe on 'a brilliant contribution to the recruiting campaign'.

Figure 48.

Poster produced by Lord Northcliffe's *Weekly Dispatch* in November 1914

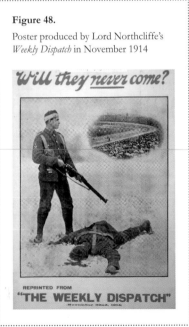

Figure 49.

Postcard of an 1885 photograph and possible basis for the Leete drawing

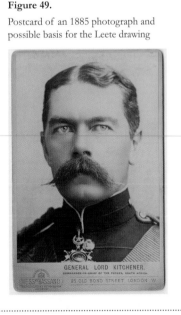

Kitchener - The Man, the Poster and the Legacy

When we think of Lord Kitchener, the face that springs to mind to most of us is the one remembered from the poster and we feel that we know the face. However, this face is not that of Kitchener at all but of Alfred Leete's drawing. But where did Leete find his reference?

There are almost one hundred and fifty photographs and paintings of Kitchener in the National Portrait Gallery, many done between 1885 and 1900, and these can be seen on the gallery's website. Some of these portraits were reprinted as cards, which enjoyed a wide circulation, as well as being used in magazines and newspapers over the next twenty years. There has been much discussion among historians about which photograph Leete used as the basis for his representation of Kitchener. Leete may well have visited Alexander Bassano's studio and selected one of his photographs – it was just a mile from *London Opinion*'s Southampton Street offices in Covent Garden to the society portrait photographers's studio in Old Bond St – and there were a lot to choose from. In addition to these images, other photographs will have been available and the nearby Strand was the sort of thoroughfare that would have had stationers, as well as Charing Cross station, selling them.

Although it is the opinion of the authors that the poster was based on a photograph from the period 1885 to 1890, the Imperial War Museum claims it was based on a photograph that it holds, referred to as Q56739 (Figure 50). This was taken around 1913 and shows Kitchener as he then was – a much older man.

When looking at the National Portrait Gallery's website images,

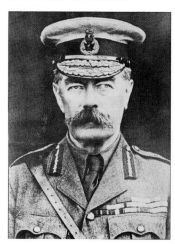

Figure 50.

Kitchener in 1914 – a photograph said by the IWM to be Leete's source

Figure 51.

Photograph taken in 1890, another contender for the source of the Leete drawing

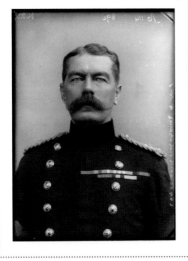

care must be taken with the dates because its collection includes the original photographic plates as well as prints and cards that reproduced the many images. Sometimes, what appear to be identical images can have different dates attached to them. So, for example, x127983 is a cabinet card with a date of 1885 and x127982 appears to be an identical card (and it is certainly looks to have been printed from the same original photograph) but it has a date of 1895. Bassano licensed the images many times to various magazines and printers, such as J. Beagles & Co, as well as printing cabinet cards himself. He will have run off prints whenever Kitchener's name was back in the news.

Several cards used a straight-on Bassano photograph taken in 1899 or 1890 (half-plate glass negative, NPG x96369), which is another contender for the image used by Leete for his artwork (Figure 51). We are not suggesting any specific print or postcard because this image was published many times in many forms. However, this negative was issued as a postcard, by F.W. Woolworth & Co among others, before the war and again after Kitchener's death. The NPG has a version, x193879, which it dates as 1899, but this is the negative's date: the card was clearly published to mark Kitchener's death, probably in 1916. To compare the options for Leete's source, the authors made direct comparisons by transposing the faces of the various photographs and NPG x96369 seems to give the closest match (see Figure 52). The artist possibly used it not only because it portrayed Kitchener as a heroic, handsome man, but also because the image would have been well known to the public.

Figure 52.

Had Kitchener's photograph face been used, the effect would be different (right)

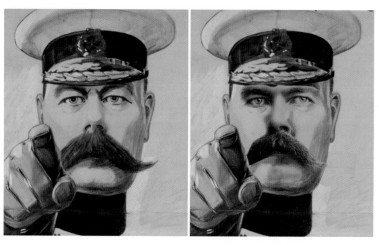

Whichever specific image was used by Leete, it seems clear that the original photograph behind Leete's chosen reference source was taken between 1885 and 1900 – a man a lot younger than the man in charge of recruitment in 1914 – and from the poster image came the face of Kitchener we know today.

Relatively few portraits exist of Kitchener after 1900, although there is a flattering painting of him from 1915 by A. Davies in Cheltenham Art Gallery. However, Figure 50 from 1914 shows what he really looked like at the time, a far older and less healthy person.

Leete took some artistic licence with Bassano's image. Kitchener had a divergent 'squint' and Leete removed this divergence, focusing the gaze directly on the viewer. In addition, he increased the area around the eyes and drew the face slightly longer and more square; the moustache was drawn larger and blacker and forms a massive arrow in the centre of the picture. Figure 52 shows the difference that would have resulted had Leete accurately copied the photograph.

Kitchener had a reputation for his 'piercing gaze' but this was perhaps due to his squint and not the image that has remained with us from the face that Leete drew. These staring eyes remove the distinction between Kitchener the poster and Kitchener the general, contributing to the victory of the former over the latter. The general's eyes left a deep impression on his contemporaries: 'Their colour is quite beautiful [a journalist wrote] – as deep and as clear a blue as the sea, in its most azure moments – and they look out at the world, with the perfect directness of a man who sees straight to his end.' Kitchener's eyes are discussed again, as an epitome of his life and character, in the official three-volume biography published in 1916, shortly after his tragic death in the wreck of the *Hampshire*: 'Even the eyes, on whose steely qualities so many have dwelt, were not young or brilliant – too much sand had blown in them for that; and there was a slight – a very slight – divergence between them...' A contemporary journalist indicated the same detail, in a more disparaging tone, while Kitchener was still alive:

> About the eyes of Kitchener it may be said without offence that the terror they inspire is heightened by a squint which has tended to grow more pronounced with age ... they would be difficult eyes to face, but with this irregularity they fill certain men with a veritable paralysis of terror. Someone who knows him very well has described to me the effect of those eyes upon people who meet him for the first time: 'They strike you,' I was told, 'with a kind of clutching terror; you look at them, try to say something, look away, and then trying to speak, find your eyes returning to that dreadful gaze, and once more choke with silence.'

For Kitchener's admirers, even his slight physical defect, not visible in the posters, became part of his posthumous legend: 'His gaze was somewhat strange, due, no doubt, to a slight divergence of the visual axes – a gaze which no one talking to him could wholly meet, however boldly he might stare. The Sphinx must look like that.'

Kitchener - The Man, the Poster and the Legacy

Leete's pointing finger design was very successful, but is far from an original idea. A 1906 poster for BDV, then a leading brand of cigarettes that was owned by Godfrey Phillips, showed a pointing man whose eyes were in the very centre of the poster and which consequently 'followed the observer everywhere, as did the pointing finger' (Figure 53). W. Macqueen-Pope, an authority on the British stage, wrote about some of the people who worked for David Allen & Co, the poster printers:

Figure 53.

Advertisement for BDV cigarettes, in the early 1900s

> 'There was James Motherwell, a fine, good-looking man from Belfast [whose] face became famous on a nationwide scale. Allens, who did much commercial as well as theatrical work, produced a poster for a famous firm of cigarettes – BDV. It showed a packet of the cigarettes and a very good-looking dark man ... That man was James Motherwell.'

The paragraph goes on to mention that Motherwell was dead. Research in the Commonwealth War Graves Commission records reveals that he was a private in the Dorsetshire Regiment who died aged 41 on 18 November 1917. He is buried at the Baghdad (North Gate) War Cemetery, in what was then Mesopotamia and is now Iraq.

Figure 54.

Pointing finger poster on a wall in about 1900

Figure 55.

Pointing man advert from *Pearson's* magazine (June 1907)

Even if Leete had not seen the BDV cigarettes drawing, the pointing technique was used by other advertisers and frequently reproduced in magazines. Figure 54 clearly shows its use on a poster in the early 1900s and Figure 55 shows an example of a pointing man in an advert for 'The Power Within' from *Pearson's* magazine (June 1907). *Pearson's* was one of the biggest illustrated monthlies and Leete would have had an eye on it – he certainly did colour covers for the magazine in 1921. Another example, for a consumption cure, in Figure 56, is one that Leete almost certainly would have seen. Why? Because it's from *London Opinion* in 1910, when Leete was an established illustrator on the magazine, regularly doing covers as well as drawings inside. In fact, the main illustration on the theatre page in that very

Figure 56.

Pointing man advert from *London Opinion* (17 September 1910)

Consumption Can be Cured

Derk P. Yonkerman, Specialist, whose Discovery of a Cure for Consumption has startled the World.

Marvellous as it may seem after the centuries of failure, a cure for Consumption has at last been found. After twenty years of almost ceaseless research and experiment in his laboratory the now renowned specialist, Derk P. Yonkerman, has discovered a specific which has cured the deadly Consumption even in its far advanced stages. In many cases, though all other remedies tried had failed and changes of climate were unable to check the progress of the disease, this wonderful specific has conclusively proved its power to cure.

Whatever your position in life may be, if you are in Consumption, or suffer from Asthma, Bronchitis, Catarrh or any throat or lung trouble, this cure is within your reach, for it is a home treatment and need not interfere in any way with your daily occupation. Prove for yourself its healing power.

ABSOLUTELY FREE

Simply send your name and address to the Derk P. Yonkerman Co. Ltd., Dept. 87, 6 Bouverie St., London, E.C., and they will post to you a free trial treatment of this remarkable remedy.

Don't hesitate or delay if you have any of the symptoms of Consumption. If you have Chronic Catarrh, Bronchitis, Asthma, pains in your chest, a cold on your lungs, or any throat or lung trouble, write to-day for the trial treatment and full instructions, and cure yourself before it is too late.

same issue of 17 September is one of Leete's. Such adverts are a clear potential source of inspiration for Leete's pointing Kitchener.

The text on the poster can be regarded as being just as important as the graphic image. The magazine cover had the words 'Your country needs YOU' (the words we remember) and the recruitment poster reads 'BRITONS [Kitchener] wants you' using a very similar typeface. Words such as 'needs', 'wants' and 'you' would have had a strong effect on readers at this time and copywriters such as Eric Field used the pronoun 'you' freely in their copy. Similarly, on the front cover of the *London Opinion*, Leete's drawing of Kitchener was accompanied by two messages: 'This paper insures YOU for £1,000' and '50 photographs of YOU for a shilling'.

Such was the success of the *London Opinion* cover that the magazine quickly reproduced it as a poster – and the artwork as a poster found its way on to another cover in November 1914 with the long arm of Kitchener threatening the prospect of conscription (Figure 58).

Figure 57.

Leete's original artwork

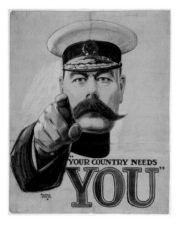

Figure 58.

London Opinion suggests conscription is nigh in November 1914

Without doubt, Leete had been exposed to the pointing man idea; as a cartoonist, he will have known Kitchener's face better than most people in Britain; and he will have read the texts in Field's adverts. So, when the war broke out, he was in the right place to dash off the 'Your Country Needs You' painting for the *London Opinion* cover. The genius was in taking all those elements, keeping things simple and putting them together in such a memorable way. And, in this context, genius is not too strong a word, for, as we shall demonstrate, Alfred Leete created the most influential image of the twentieth century, in the process turning Kitchener into a global icon.

17

The Kitchener
poster copied

Soon after it came out in 1914, Alfred Leete's 'Kitchener' artwork was used for three posters. The first was printed by the publishers of *London Opinion*; the second was printed by the Victoria House Printing Company with the permission of the magazine using different wording, 'Britons. [Kitchener] Wants You'; and the third was printed by David Allen as poster number 0200 with Leete's original wording but with flags and text setting out the terms of enlistment. The number of versions of the Kitchener poster – plus PRC 113, the official Kitchener poster that did not use Leete's image – helps explain the confusion around much of the discussion of the poster. The main four are shown in Figure 59 with complete details in Table 1 (at the end of this book) showing the four images and the basic facts around each one.

Leete's idea was also copied with good effect by others, initially by other countries to aid their own recruitment or fund-raising efforts (Figure 60). The most famous example was used in the United States, with a strategy that mirrored events in Britain. On 6 July 1916, *Leslie's Weekly* ran a James Montgomery Flagg cover for an issue of the US magazine that mimicked Leete's image but with a pointing Uncle Sam. The wording ran: 'What are you doing for preparedness?' (Figure 61). Seven days later, *Leslie's* used Flagg's artwork in an advert. The magazine's publishers were selling a four-volume set called *The Great Republic: An Illustrated History of the American people*. Beside the

Martyn Thatcher & Anthony Quinn

Figure 59.

Leete's original magazine cover and three 'Kitchener' posters based on the same artwork

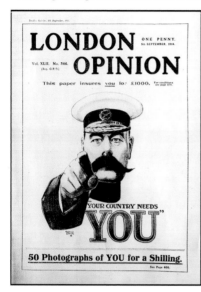
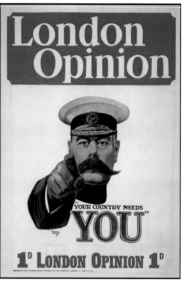
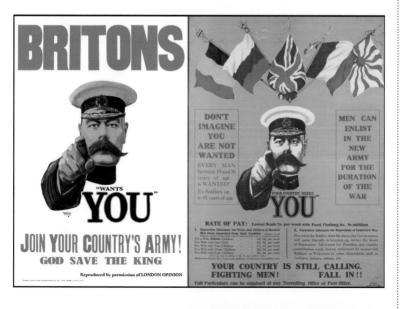

Figure 60.

Some of the many recruiting posters produced by other countries at the time

image of Flagg's Uncle Sam, the advert's text – playing on the forthcoming presidential election of 1916 – reads (Figure 62):

> Know the facts about your own country. You are soon going to exercise your most important right as a citizen of this great republic by helping to decide who is to be your next president. To make a wise choice of candidates it is important that you should know American facts bearing on the vital questions of the hour.

The copy goes on to echo the previous week's appearance of Flagg's Uncle Sam by linking to the issue of 'preparedness' by stating:

Martyn Thatcher & Anthony Quinn

Trade conditions have made it possible for us to secure on favourable terms a few sets of these intensely interesting volumes, and as our own contribution toward real PREPAREDNESS at this opportune time we will offer these sets, while they last, to quick buyers at a wonderful bargain.

Just as there had been a variant of Leete's cover on *London Opinion*, Flagg did a variant of his image for a later edition of *Leslie's* and used it for a recruiting poster (Figure 63).

The Leete poster design was mimicked by other nations between 1915 and 1919. A poster of a similar style was posted outside the Bank of New Zealand in 1915 and a Canadian recruiting poster of that year uses the same iconography. Similarly, a recruiting poster for South African troops to fight against German colonies used a version of Leete's Kitchener with the text: 'South Africans! You're Wanted. Roll Up!' The campaign was promoted by the country's prime minister, Louis Botha, one of the generals who had led the fight against the British in the Second Boer War.

Eventually, all sorts of organisations and people used the pointing

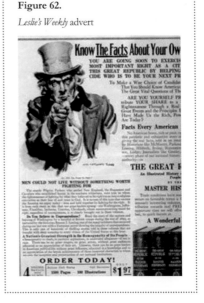

Figure 61.

Leslie's Weekly cover (6 July 1916)

Figure 62.

Leslie's Weekly advert

Kitchener to promote their ideas, goods and events. Thousands of imitations have followed over the years and most readers will have seen one. A browse in a web search engine for the words 'Leete Kitchener poster' or '*London Opinion* poster' or 'Kitchener poster' will produce a plethora of images.

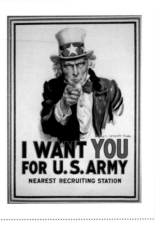

Figure 63.

Flagg design on a US recruiting poster with the 'I Want YOU' wording (1917)

18

Was the Kitchener
poster effective?

Much has been written about the effectiveness (or not) of Alfred Leete's Lord Kitchener poster as a recruiting tool but the evidence is anecdotal. In any case, it would be impossible to separate out the effect of one recruitment method from the myriad of efforts to work out with any certainty how many men were persuaded to enlist because of it. The recruitment campaign was certainly regarded as effective. On 16 November 1914, the prime minister gave a statement about the recruitment numbers:

I can give the total number of persons who have been recruited. Roughly – I do not want to commit myself precisely – since the week ending the 10th of August, approximately – I do not say much more, but certainly not less than – 700,000 recruits have joined the Colours, and they are still coming in very steadily. They have nothing to do with the Territorials. We must add to that a very large number of Territorials, at least 200,000, and I think more. I do not think that I should be very far short of the mark if I said that a million men had been recruited since the first appeal was made in the first week in August.

By Christmas, another 218,000 names of men willing to serve had been collected from the distribution of householders' forms by the Parliamentary Recruiting Committee to country towns and districts, and the forms were then going out to large towns and cities. Policy changed in the new year, however, with actual numbers no longer being released. Instead, Viscount Midleton was reported in *Hansard* as telling parliament the figures were 're-markable' and gave percentages of recruits raised per 10,000 of the population, deliberately so the exact figure was obscured. Midleton raised a concern that the industrial areas were bearing too high a price compared with rural areas. From 4 August to 4 November 1914, the southern district of Scotland furnished 237 recruits per 10,000 of the population; Warwickshire and the Midland counties, 196; Lancashire, 178; London and the Home Counties, 170; Yorkshire, Durham and Northumberland, 150; Cheshire and part of Lancashire and the neighbouring Welsh counties, 135; the North of Ireland, including Dublin, Wicklow, Carlow, and Kildare, 127; Notts and Derbyshire, 119; North of Scotland 93; West of England, 88; East of England, 80; and in the South and West of Ireland, 32 per 10,000 of the population The cost incurred by the PRC was estimated at £10,000. By May, forms to households had produced the names of 300,000 men willing to enlist. By the end of 1915, 2,466,719 had voluntarily enlisted. In total, 5.7 million men served compared with 3.8 million in the Second World War.

Kitchener - The Man, the Poster and the Legacy

In 1997, an article in the *Imperial War Museum Review*, 'Kitchener wants you and Daddy what did you do in the Great War? The myth of British recruiting posters' by Nicholas Hiley claimed that the Kitchener poster was not well known during the war, but became iconic after the museum acquired Leete's artwork and used the image on its publicity. Hence, the Imperial War Museum claims credit for the public association of the image with the war. The article points out that the poster was not recorded in the files of the PRC, in the War Office, or the published accounts of the printers, David Allen & Sons, or in the newspapers and magazines, which at the time frequently criticised such posters. There is no evidence that Leete's was an official design, for it did not carry a PRC number or a Stationery Office imprint. It is not referred to in PRC minutes, listed in the poster catalogues or included in the official summary of its work. Indeed, the PRC issued its own, officially called 'Kitchener poster', which had wide circulation (Figure 64). This poster, PRC 113, was printed in 1915 and quoted from a speech Kitchener gave at the London Guildhall in July stressing the call of duty.

Before 2014, there were only three known copies of the 'Britons' poster that used the Leete artwork. These were held by the Imperial War Museum, State Library of Victoria Melbourne and the Robert Opie Collection. However,

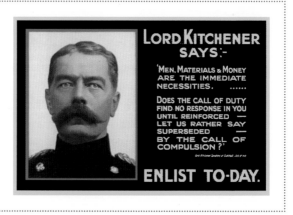

Figure 64.

The 'official' Kitchener poster (PRC 113)

the commemoration of the war's centenary brought out a major collection of posters that were sold by the auctioneers Onslows in its Great War Auction of July 2014. A copy of the 'Britons' poster fetched £27,000. The sale was of one of the most complete Parliamentary Recruiting Committee poster collections in recent years. They were found in an attic in Kent by Arthur Maxted, who had inherited them thirty years before but had not appreciated what they were. Two more copies of the 'Britons' poster then appeared, making a total of six copies.

In an interview with one of the authors in July 2010, Richard Slocombe, senior curator of art at the Imperial War Museum, repeated the view that the poster itself received little exposure during the war years. The effectiveness of Leete's rendition of Kitchener, it claims, has to be measured against the almost complete absence of contemporary references to it, either as the *London Opinion* front cover or as it was later issued by the Victoria House Printing Company with the words 'Britons, [Kitchener] wants YOU'.

It is, however, not difficult to explain the lack of reference to an image regarded as widespread and that left such an impression on so many people: it was not official, therefore, would not have been displayed at recruiting offices, railway stations and other sites that were part of the government's network, although we do know that the poster was publicly displayed from contemporary photographs. It was privately produced in relatively small numbers and its distribution network will have been very different, too. Copies of the poster may well have been sent out with bundles of magazines to be displayed outside newsagents, as much to encourage sales as to recruit troops. As such, many of the posters will have been on display for just a week or even a few days before being replaced by a promotional poster for a different issue or magazine.

In 2013, *Your Country Needs You* by James Taylor repeated the Nicholas Hiley argument and cited the lack of evidence both written and photographic. This is misleading because there are authenticated photographs of the Leete poster displayed at Chester Barracks, on a recruiting tram in Ulster and as part of a display outside Liverpool Exchange Station, offering every indication that the poster was distributed across the country.

Kitchener - The Man, the Poster and the Legacy

The photograph of the poster outside Chester Barracks (Figure 65) has been published in two books, *The Cheshire Regiment* by Ronald Barr and *Chester* (vol. 2) by Karlyn Goulborn and Gillian Jackson. The original photograph taken in 1915 was traced to the Chester Regiment museum archives. The figure is said to be a Sgt-Maj. Edwards, a reservist of the regiment and the landlord of the nearby Saddle Inn.

The picture of the Ulster tram (Figure 66) appeared in a supplement to the *Manchester Guardian* newspaper, the *Manchester Guardian History of the War* published between 1914 and 1919 and later released as a hardback.

The 'Britons' poster also appears alongside other contemporary posters in a photograph of a display outside Liverpool's Exchange Station (Figure 67).

Figure 65.

London Opinion 'Britons' poster outside Chester Barracks in 1914

Figure 66.

London Opinion poster among others on an Ulster tram in 1914

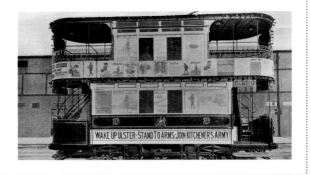

The photograph is part of the Horwich collection, which represents the work of photographers employed by the Lancashire & Yorkshire Railway and its successors, the London & North Western Railway, London Midland & Scottish Railway and British Railways between 1890 and 1979. In 1914, this would have been the Lancashire and Yorkshire Railway, which ran routes through Liverpool. The date of the photograph, 15 December 1914, is taken from the handwritten log of the photographer and the authors have seen the original full-plate glass negative. The poet Siegfried Sassoon frequently lodged in the hotel adjoining Liverpool Exchange Station and it was there in 1917 that he wrote 'A Soldier's Declaration', a watershed in attitudes towards the war that appeared in the press and was read to the House of Commons.

Counter to the argument that the specific words 'Your Country Needs You' were never on a poster is the fact that within a year of the *London Opinion* cover, a poster was produced by printers David Allen & Sons with Leete's image and the words 'Your Country Needs You' (Figure 68). There is an example of this poster in the Imperial War Museum. Furthermore, there is a 1915 Topical Press Agency photograph of this poster, with Leete's image looking at us from behind survivors of the Lusitania sinking. The picture is on the Getty Images website and is captioned as being taken outside the town hall in Cobh, County Cork.

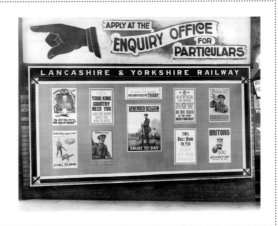

Figure 67.

Display outside Liverpool Exchange Station in December 1914 (National Railway Museum)

Kitchener - The Man, the Poster and the Legacy

Figure 68.

Poster using the words 'Your Country Needs You' (David Allen, No. 200)

Immediately after the war, the Imperial War Museum, which was founded in 1917, considered the artwork important enough to accept it from Leete. Claims that it was the Imperial War Museum that promoted the image must be balanced against the lack of records about any of their publicity bearing the Leete image and it was not included in a touring exhibition of war posters organised by the museum in 1917 (although the Leete poster was featured in an exhibition in 1919). We know there were at least three posters using the Alfred Leete artwork with varying texts. Claiming that a poster with a particular image and a specific text may not have been widely circulated is an exercise in semantics. Claiming that the many references to the poster in veterans' memoirs and interviews are incorrect because of their failing memories is giving the people concerned little credit.

As noted in the previous chapter, several European countries considered the Leete idea so impressive that they quickly did their own versions. In the US, New York artist James Montgomery Flagg copied Leete's image, first for a cover of *Leslie's Weekly* magazine, then for advertising and then for a recruitment poster. Four million copies of Flagg's 'I want YOU for the US Army' poster of 1917 were printed. A poster of a similar style was posted outside of the Bank of New Zealand in 1915 and a Canadian recruiting poster of the same year uses the same iconography. An adaptation of Leete's poster, featuring a bearded man in a turban pointing at the viewer, was used in India with the text 'Have you bought war bonds or not?' in Gujarati towards the end of the war.

It is clear from the discussion above that the poster *was* on display around the country and that it *was* well known enough at the time to be copied by others. However, we have to address the question as to why so few copies of the Leete posters exist today compared with hundreds of copies for many of the official PRC posters. Examination of the recruiting posters in various collections reveals that many are in pristine condition, leading to the conclusion that they were never used. When the poster campaign fizzled out, the government had thousands of posters on its hands: many were destroyed, many were sent overseas and many were circulated to schools in this country. The website of Onslows, the poster auctioneers that sold the Maxted recruiting poster collection for £90,000 in 2014, casts some light on this:

> An additional discovery of a suitcase added more posters, virtually in pristine condition, with a file of correspondence from 1917–21 throwing light on the background of the collection. It seems likely that Arthur Maxted's grandfather was actually involved in selling the posters either on behalf of HM Government's Stationery Office or on his own account, maybe the first record of a poster dealer. The posters were being sold in complete sets to libraries, institutions and private individuals around the world. It is noted that a set of the PRC posters was selling for around 100 guineas (£20,000 in today's money).

In fact, in 1921, HMSO published the *Catalogue of War Literature Issued by H.M. Government, 1914-1919*. This 92-page, sixpenny booklet included 'recruiting, war savings and other pictorial posters, and the more interesting of the numerous publications bearing upon the war, some of which have not previously been offered for sale'. The foreword makes it clear the offerings are aimed at collectors and people wanting 'literary souvenirs' of the war. The booklet trades on the rarity of the posters:

> As no general distribution of sets of posters has been made and the remaining stocks are very limited, they will undoubtedly appreciate in value as time goes on… offers are therefore invited for complete sets

of all posters, of particular series, or for single copies… Individual copies will have considerable interest for those who have seen service in the locality depicted, and the reproductions, which have been printed in a highly artistic manner by [the Newnes magazine] *Country Life*, are well worth framing.

However, the only 'Lord Kitchener' poster it lists is PRC113 (see Figure 64) in two sizes (30 x 20 and 50 x 40 inches).

The popularity of the Kitchener poster and the number of people who saw it obviously cannot be gauged by comparing the number of unused remaining copies. As in any historical debate, lack of documentation for an artefact does not preclude its existence. The worldwide reproduction of the image seems to give every indication that it was widely known during the war and also that it was seen as a powerful recruiting tool.

One aspect of Great War poster advertising that has received little attention before has become apparent in the research for this book as photographs have come to light of street scenes showing how posters were actually displayed. Contemporary photographs reveal that recruiting posters were often pasted with a number of posters – often identical ones – in the same area, even on the same wall, reinforcing the message.

However, there is no indication that this technique of multiple images was based on theory or in any way suggested by the PRC; one has the impression that the decision to paste up many copies was probably taken by the person who put them up – told to 'paste 'em up on that wall', he probably did just that! There is equally no suggestion that anyone was consciously aware of the powerful effect of using these multiple images. Warhol used this technique in the 1950s to great effect, realising that the same repeated image, particularly of a face, had a powerful effect – emotional as well as visual.

Remember too, that most of these posters were in brilliant colour, not the faded black and white images we see in the old photographs. It is no wonder that people remembered the 'staring face of Kitchener' after being faced by a

Figure 69.

A simulation showing how powerful large repeated images can be – a technique employed by Andy Warhol

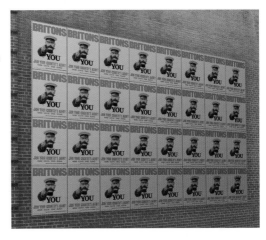

Figure 70.

A simulated picture illustrating the power of colour on a tram at Chester station

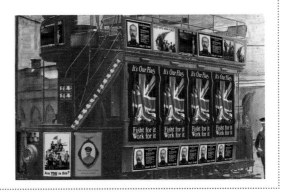

wall of his staring eyes and his pointing finger – you don't need thousands of individual posters all over the place – one colourful array like this in a prominent place will certainly have a great effect (Figures 69 and 70).

Alfred Leete may not have understood the added influence of his image being used in this way and perhaps even the men and women who posted the bills themselves didn't realise they were using such a powerful marketing technique.

Kitchener - The Man, the Poster and the Legacy

Alfred Leete's Kitchener artwork has become an icon, not only of the First World War but also as an image that demands our attention on several levels and for many reasons. Of course, it is an image with which we are familiar and this must in some way appeal to our senses. Also, the text used requires little change to fit many circumstances. There is another characteristic that is not often appreciated. We are used to posters designed to get us to need the product they depict, whereas this poster reverses this and claims that the object of the poster needs us! However, there is another, far more complex, reason that this image draws us to it, a technique that has been used for almost two millennia by artists and painters to the same ends.

The academic world offers an approach called transactional analysis, which was developed in the 1980s to study communication. This would recognise Kitchener's pointing finger as typical of a 'critical adult', an attitude that requires compliance and is not open to question. Yet, attitudes change over time; a father in the 1950s could wag his finger at a child and say 'You will do it because I say so' (as one of the authors certainly remembers) – but few fathers would get away with this today!

Some commentators would say the strength of the Kitchener image is based on its place in a tradition of classical art and pagan culture. Religious ritual and imagery have supplied the most telling expression of elemental impulses

Figure 71.
Detail from the Sistine Chapel by Michelangelo (1508-12)

and it may be that pictorial forms are mnemonics for such impulses, which can be transmitted and transformed down the generations. Thus, when we view an image we conjure up past associations and are influenced by them. The Sistine Chapel ceiling by Michelangelo springs to mind (Figure 71).

There are many theories related to posters. According to one academic, William Mitchell:

> The picture is a material object, a thing you can burn or break. An image is what appears in a picture and what survives its destruction – in memory, in narrative and in copies and traces in other media.

The writer Susan Sontag claims that poster artists are usually plagiarists (whether of their own work or others') and in *Picture This*, a compilation of writing on Great War posters, Pearl James agrees that posters copy, parody and otherwise repeat eye-catching, memorable and significant images. Back in 1918, Matlack Price and Horace Brown wrote:

> The poster must attract attention in the face of a thousand distractions and competitors for attention, and must make itself understood by people who are usually on the move. It calls for a larger size, a forceful use of design and colour and a simple presentation of its message with the medium of print. It must tell its story forcefully and at once. It must be so designed as to be seen in its entirety from a passing vehicle. If the message is rendered in a way too complex for this instantaneous view, there is too much in the design.

The Leete image's power may stem from many sources. In a 2001 case study, Carlo Ginzburg, an Italian historian, claims that the Kitchener poster's popularity came from the use of bold colour, and invocation of familiar 'pictorial traditions' that use 'frontal, all seeing figures with fore-shortened pointing fingers' to 'command authority', echoing of art historical tradition, coupled with the sheer number of imitators. The historian Nicholas Hiley leads to a different conclusion. He argues that Leete's image, and the recruitment campaign of which it

became part, 'provoked considerable opposition' which was visible precisely through the proliferation of ironic parodies. The fact that the Kitchener poster, he argues, has become an icon of the war tells us not about its success during the recruiting campaign but about its legacies in 'later ironic use'. In his view, we have inherited a myth of the poster's power as a recruiting propaganda tool.

It is arguable that the image itself is strong partly because of subliminal links to classical art: Ginzburg points to the 'Pathosformel' formula of emotion, whereby a form evokes pity or sadness, espoused by the German art historian Aby Warburg: 'It was pagan culture, both in religious ritual and in imagery, that supplied the most telling expression of elemental impulses (Pathosformel). Pictorial forms are mnemonics for such operations; and they can be transmitted, transformed and restored to a new and vigorous life, wherever kindred impulses arise.'

Ginzburg explains that in the thirty-fifth book of *Natural History* – a section devoted to Greek and Roman artists – Pliny the Elder refers to Famulus, a painter from the time of Emperor Augustus: 'To him belonged a [painting of the goddess of wisdom] Minerva who viewed the viewer no matter where he looked from.' Outside the European classical tradition on the Indian subcontinent, Buddhist caves carved into a hillside at Ajanta cover a period of eight hundred years, starting from the second century BC. The paintings and sculptures are regarded as among the finest surviving examples of Indian art and include faces on ceilings where the subject's eyes follow the viewer around the cave.

Apelles, a fourth-century BC Greek regarded as the greatest painter of antiquity, painted Alexander the Great holding a thunderbolt, in the temple of Artemis at Ephesus, where the figure has 'the appearance of projecting from the surface and the thunderbolt seems to stand out from the picture'. A fourth-century BC Greek artist, Pausias, Pliny continues, invented a method of painting where to show the long body of an ox he painted the animal facing the spectator.

Two millennia later, echoes of these reports can be found; Ginzburg quotes Mont Abbott, a young farm-worker from Oxfordshire, writing:

The gwoost [ghost] of Kitchener had been fading his finger at me for some time on they washed-out posters outside the Post Office, 'Your King and Country NEED YOU'.

Henry Davray, writing in 1916, reinforces the theme:

The Central Recruiting Committee posted on the walls of London and all over Britain a poster displaying an enormous full-face portrait of Lord Kitchener. From whatever angle it was regarded the eyes met those of the onlooker and never left them; and on one side in large letters was the laconic appeal: Kitchener wants more men.

These observers may never have read Pliny the Elder, but when we read the words 'from whatever angle [the poster] was regarded, the eyes met those of the onlooker and never left them' we could wonder whose image is being described here, Minerva's or Kitchener's? Whose is the monstrously big finger, Kitchener's or Alexander's?

Referring to *De Visione Dei* (*On the Vision of God*) by the German philosopher Nicholas of Cusa (Cusanus) from 1453, Ginzburg explains that to give his readers an idea of the relationship between God and the world, Cusanus wrote that the most appropriate image they could picture would be the face of somebody who sees everything.

In 'Blessing Christ' (Figure 72), Antonello da Messina modified the hand by introducing a foreshortening. Much has been written on this, but in the view of Ginzburg he may have been inspired by Pliny's passage on Alexander the Great – the Italian translation appeared in Venice in 1476, about the time Antonello revised his painting. Michelangelo shows an obvious influence in the Sistine Chapel frescos – projecting fingers, gesticulating hands and bold foreshortenings stress spatial and narrative relationships. A similar argument can be used for Pontormo's 'Nude Study' from about 1525 (Figure 73).

We may be able to interpret Kitchener's pointing finger as a secular, foreshortened version of Jesus's horizontal gesture in Caravaggio's 'Calling of St Matthew' (Figure 74). In both cases we have a call – a call to arms, a

religious call. The stern glance, the stabbing finger, the perspective as though seen from below, must have usually elicited a feeling of awe but the poster's aim was to arrest the viewer's attention and bring him to a halt. In 1895, the Lumière brothers plunged cinema audiences into terror by projecting their film, *Arrival of a Train into the Station of La Ciotat.* The Kitchener poster relies on the same visual devices and was addressed to an audience becoming familiar with cinema and its visual tricks.

Both Ginzburg and James write that Kitchener probably inspired George Orwell's chilling icon of bureaucratic warmongering, Big Brother in *Nineteen Eighty-Four* (Figure 75). Eric Blair (aka George Orwell) was eleven years old when the war started. In the 1949 novel, the reader is confronted with two descriptions:

> [A] coloured poster, too large for indoor display ... tacked to the wall. It depicted simply an enormous face, more than a metre wide: the face of a man of about thirty-five, with a heavy black

Figure 72.

Antonello da Messina's 'Blessing Christ' (c1465)

Figure 73.

Pontormo's 'Nude Study' creates intimacy with the viewer (c1525)

Figure 74.

Caravaggio's 'The Calling of St Matthew' painted in 1600

moustache and ruggedly handsome features. It was one of those pictures which are so contrived that the eyes follow you about when you move BIG BROTHER IS WATCHING YOU, the caption beneath it ran...

...A new poster has suddenly appeared all over London. It had no caption, and represented simply the monstrous figure of a Eurasian soldier, three or four metres high, striding forward with expressionless Mongolian face and enormous boots, a sub-machine gun pointed from his hip. From whatever angle you looked at the poster, the muzzle of the gun, magnified by the foreshortening, seemed to be pointed straight at you.

One 2004 study, 'Pointing out of the picture' explains that all it takes for the eyes in an image to follow you round the room is to have the person in the painting, or photograph, look straight ahead, because our visual perception takes care of the rest. The authors describe paintings being ascribed 'almost magical powers' because of the effect and refer to art historian Sir Ernst Gombrich's 1960 study of Leete's poster. The study concludes

Figure 75.

Still from the 1956 film adaptation of George Orwell's *1984*

that 'no special gift or training is involved' and the only 'trick' is to have the subject of the picture to look (and/or point) directly to the lens. The researchers claim that when we observe a picture on a wall the visual information that defines near and far points is unaffected by the viewing direction. We interpret this perceptually as if it were a real object, which is why the eyes appear to follow you as you change your viewing direction. This phenomenon is because of the unique perceptual aspects of viewing a picture; we perceive the object depicted in a painting as a surface in three-dimensional space, but we also perceive that the painting is a two-dimensional surface hanging on the wall. Thus, when we look at such a picture, we have these two perceptions simultaneously and it is difficult to make sense of that conceptually – an issue that has fascinated people for hundreds of years.

Even in 1859 this subject was researched by La Gournerie, a French researcher who proposed a mathematical analysis of why eyes in a painting seem to follow viewers. More recent study indicates that La Gournerie had the basic idea right, but his mathematics was wrong – later researchers have provided a better mathematical analysis.

Possibly the best summary of the strengths and weaknesses of Leete's drawing was provided by Maurice Rickards, the graphic designer and ephemera encyclopaedist. He used a simplified version of Leete's Kitchener design as a symbol on the title page of his 1968 book of posters. He sums up the power of the image:

Martyn Thatcher & Anthony Quinn

Your Country Needs YOU is by no means a major work, but its posterly simplicity has impact far in excess of any of its contemporaries. His lordship's accusing finger has haunted Britons since they first saw it. It is the archetype of all wartime father figures, crib-source for a host of mimics. Like the man himself – brooding, compulsive and final – it has entered into the mythology of the nation; it has become a trade-mark figure for World War I. In a multitude of contexts, sacred and profane, it has been revived in parody. In the wave of mock nostalgia that swept the last of the nineteen-sixties, the image was again revived – this time as a pop-art decoration piece. Kitchener … would have been greatly mystified.

Such a wave of mock nostalgia would see the poster 'Keep Calm and Carry On' establish a similar popularity after 2000. Like the Leete design, it comes with its own mis-remembered history, for, having been intended as a poster to bolster morale in the event of a wartime disaster, it was never actually used. Instead, its utility is based on treating austerity with nostalgic irony. Paul Atterbury, a specialist on the BBC television programme *Antiques Roadshow*, wrote to the authors to make an interesting point:

Figure 76.
John Everett Millais,
'The Boyhood of Raleigh'

Kitchener - The Man, the Poster and the Legacy

Some time ago a national newspaper published an article stating that there was only one surviving original 'Keep Calm and Carry On' poster and it was in the Imperial War Museum and priceless. Well, I have one on my wall, and we had a lady on the *Roadshow* a couple of years ago with seventeen. So they are rare, but there are probably quite a few out there. They were all issued to post offices and government buildings during the summer of 1940, ready to be displayed if required. Unused, most were simply thrown away. The survivors probably lurked forgotten at the back of cupboards. Mine was a present years ago from a lady whose family had run a village post office. They had found a few during a recent clear-out. The seventeen on the *Roadshow* were a similar story, found rolled up in a cupboard years after the war.

Finally, in Figure 76 is a picture that graced the walls of many a mid-1900 home – the 'Boyhood of Raleigh' painted by John Everett Millais. Here, the finger points away from us but we still feel the power as our thoughts follow the direction into who knows where.

19

How did Leete's
Kitchener image stay in our memory?

ondon Opinion carried Alfred Leete's Lord Kitchener for the first time on 5 September 1914 and by the next issue was advertising postcards of the cover at 1s 4d for a hundred (though Taylor writes that no copies of these have been found). By

the end of the month the design was being issued as a private poster and the Parliamentary Recruiting Committee obtained permission to use it with amended text. Yet, as this chapter will demonstrate, the fame of the Kitchener poster meant that it was kept in the minds of the population through memory, exhibitions, journalism, parody and by being exploited as a marketing tool.

In March 1917, the war cabinet approved an idea from Sir Alfred Mond MP to create a national war museum that would record the events of, and curate objects from, the Great War. The intention was to collect and display material as a record of everyone's experiences during the war – civilian and military – and to commemorate the sacrifices of all sections of society. Because of interest from countries in the empire, it was later renamed the Imperial War Museum. The IWM has always claimed to have purchased the artwork but recent research by James Taylor indicates that the artwork may have been one of four drawings donated to the IWM by Leete himself in 1917; indeed Taylor claims that they were incorrectly catalogued at the time of acquisition.

One of the museum's first exhibitions was held in 1918 in Burlington House in London. The event hosted objects and photographs from the war, with rooms devoted to New Zealand, Australia, Britain, the Air Ministry, Canada, Royal Academy pictures and women's work. Posters were displayed in the vestibule and, although the published catalogue listed the objects and photographs in the exhibition, it unfortunately did not include the posters displayed. However, the Mary Evans Picture Library reckons the Leete posters

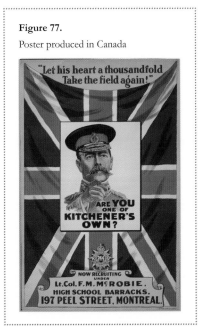

Figure 77.

Poster produced in Canada

were not displayed, though one of them did feature in an exhibition at the Grafton Galleries in 1919.

The online archive for *Hansard*, the record of parliamentary debates in both the House of Lords and the House of Commons, provides an interesting pattern in terms of use of the phrase 'Your Country needs You.' It is not recorded in the nineteenth century and comes up first in 1915 when an MP quotes a recruitment poster. It then appears twenty times more in the 1900s, although not in either the 1920s or the 1950s. In the new millennium, it has been voiced just once, in 2004.

Going back to that parliamentary coinage, in June 1915, an MP says: 'Here is a poster I got from the recruiting committee. It says, "Your country needs you." It represents a Highlander gazing down upon a village, and underneath are the words, "Is not this worth fighting for?"' This is the first time *Hansard* has the phrase being spoken. It is used again in 1916 and 1919, but then does not crop up again until the 1930s, when it is usually used in debates about the sacrifice people made in the Great War and the way the phrase gave people a stake in the country.

The *Daily Mail* reported General Sir Arthur Currie, the principal of McGill University in Canada, using the phrase 'your country needs you' in a February 1927 address to students urging them to stay in Canada and not be lured to the US.

Another set of memoirs, *Great Event*, by Horace Buckley, a former lieutenant in the Coldstream Guards, is described in an advert in *The Times* of 28 November 1930 as 'An honest, balanced story of a public school boy's war experiences from the moment he saw the poster Kitchener Wants You!'

In 1931, the Victoria and Albert Museum held an exhibition of 450 posters from around the world, of which about half were from Britain. Several posters from the Great War were shown, including two by Frank Brangwyn and one by Paul Nash. The Leete poster was not among them, but this could be because the focus of the exhibition was the art of the poster and, from the museum's point of view, it was as much about colour lithographic printing

as posters. From an artistic view-point, Leete's image would not have been a match for these as its power lies elsewhere. Work from the United States was included, including seven from the war, but Flagg's recruitment posters were not shown.

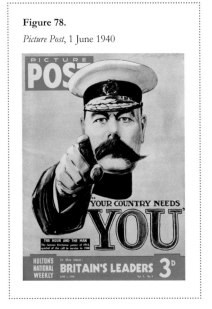

Figure 78.

Picture Post, 1 June 1940

Early in the Second World War, Leete's artwork was dusted off for the cover of *Picture Post* (Figure 78). Under Hungarian-born photojournalist Stefan Lorant, who had fled to London after being imprisoned by Hitler, and his deputy Tom Hopkinson, this large format weekly had become one of the best-selling magazines in the country, with sales of close to two million copies. The issue appeared in the same week as the Dunkirk rescue of June 1940 and, if Leete's image was in any danger of being forgotten, it was certainly back in the public eye now.

In parliament, Eleanor Rathbone, MP for the Combined English Universities in December 1941, referred back to the Great War in a debate about how to appeal to women for war work:

> The adventurous note is not really the best way to catch the best brains among women. The underlying motive can be expressed in the oldest of all appeals, 'Your country needs you'.

As for the government's slogans of the day, the *Daily Mail*'s George Murray attacked them as 'like a slab of cold pudding'. Comparing them with efforts in the Great War, he said:

> Your country needs you ... From ten thousand hoardings the compelling finger of Kitchener pointed straight to the passers-by. There was

no escaping it. That poster of the last war sticks in my mind today. I can't forget it. But what's the slogan of this war? I see one six times a day – but I can't remember it. I have to write it down. Here it is: 'Your courage, your cheerfulness, your resolution will bring us victory'.

In a similar vein, after the war, in 1949, Totnes MP Ralph Rayner, who had fought in the first war, also castigated the efforts of poster writers:

There is also a lack of guts about our slogans. I cannot remember one of them. In the last war, that finger of Lord Kitchener, pointing at one from every hoarding, touched one right on the solar plexus. That curt injunction, 'Your country needs you,' made every man want to do his damnedest. I do not know whether the long lull is responsible for the failure of inspiration on the part of our inventors of slogans.

Figure 79.

Daily Telegraph uses Leete's image on the cover of its centenary magazine in 1955

Leete's artwork was on show again at a display of old army recruitment posters held at Charing Cross Underground station and reported on in *The Times* in November 1949. The picture caption read: 'The Kitchener poster seen above was well known in the 1914-18 war' and the artwork appears to have been given pride of place in the exhibit. Four years later, an unusual female depiction of the pointing figure was on the June 20 cover of *Picture Post*. American actress Vivian Blaine was in the London stage adaption of the musical *Guys and Dolls*. Also in 1953, a Britannia class locomotive was named Lord Kitchener, joining

Figure 80.

Daily Telegraph's centenary magazine

Figure 81.

Punch re-uses the image (19 January 1955)

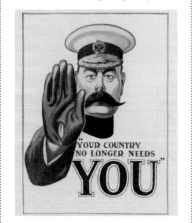

engines named after other war heroes Lord Roberts, under whom Kitchener served in the Second Boer War, and Lord Haig, who had taken over leadership of the British Expeditionary Force from Sir John French in 1915.

Another direct outing for Leete's artwork was as one of the eight images on the cover of a magazine published by the *Daily Telegraph* to celebrate the newspaper's centenary in 1955 (Figures 79 and 80). It was repeated as a quarter-page inside and identified only as a poster. In the same year, *Punch* reinterpreted the pointing Kitchener as a comment on the way it perceived Britain as turning its back on civil servants (19 January 1955) as the Anglo-Egyptian Sudan prepared to become the independent Republic of the Sudan on 1 January 1956 (Figure 81).

In 1958, Philip Magnus's *Kitchener: Portrait of an Imperialist* was published with a jacket design by Osbert Lancaster, one of Britain's best-known illustrators, who had pioneered the pocket cartoon at the *Daily Express* during the Second World War (Figure 82). The Lancaster jacket portrays Kitchener in a tarboosh (fez) as a 'pasha', an honorary title in

Egypt equivalent to a British lord. The biography identifies Leete's artwork as the poster, with no reference to *London Opinion*. The book reproduced on a full page the Leete image with a credit to the Imperial War Museum and the caption: 'Recruiting poster, 1914, designed by Alfred Leete.' Magnus describes how:

> The whole country was soon placarded with posters depicting Kitchener in the character of Big Brother, with a field marshal's cap, hypnotic eyes, bristling moustache, pointing finger and the legend 'Your Country Needs YOU'. Volunteers thereafter flowed in at a rate which strained almost to breaking-point the hastily improvised machinery for accommodating, equipping and training them.'

Magnus also repeated one of the best quotations about Kitchener, though without identifying the source:

> Mrs Asquith remarked indiscreetly that if Kitchener was not a great man, he was, at least, a great poster; and Kitchener retorted by telling his personal staff that all his colleagues repeated military secrets to their wives, except Asquith, who repeated them to other people's wives.

Under the headline 'Doing what comes naturally' the *Daily Mail* ran a picture caption story about a 1959 recruiting film for the Women's Royal Army Corps in which; 'With the impact of the Kitchener poster two wars ago, Private Wallis marches up

Figure 82.

Book jacket by Osbert Lancaster of Kitchener Pasha

to the camera for 20 seconds ... and salutes.' 'No Guards could better it,' said experts.' Clearly, the *Daily Mail* expected its readers to understand the Kitchener poster reference, even though it dated back forty-five years.

The 'your country' phrase again crops up in parliament in 1960, when an MP tells the Commons: 'Your country needs you in the teaching profession.'

All these examples have regarded Kitchener and the Great War as something to look up to. However, Magnus's biography is a turning point and changes the reading of Kitchener. It depicts the war hero as an imperialist with outdated attitudes that have little place in the modern world. This was a time when Britain was letting go of empire: India had gained independence in 1947, Malaysia in 1957 and Kenya was fighting for a release that would come about in 1963. Back in Britain, attitudes are changing, reverence is being lost and societal shackles shed. Post-war babies are booming, rock and pop are rolling, and a rebellious attitude forming among the young towards what George Melly called 'a grey colourless shabby world where good boys played ping pong'. Satire is coming and a July 1961 column in the *Daily Mail* gives an example of Leete's image being used to mock the establishment. Harold Macmillan, the prime minister, is ridiculed with the words:

We could do another version of that famous Kitchener poster of

Figure 83.

The *Daily Mail* ridicules Harold Macmillan, the prime minister

the First World War which haunted the column-dodgers and stay-at-homes with its staring eyes and pointing finger. Today the awkward question would be – But Does the Country Need YOU?

It was accompanied by a sketch of the idea (Figure 83). The thrust of that column is picked up a year later by an MP criticising the level of service pension. Commander Harry Pursey, who had started as a boy seaman and fought at the Battle of Jutland, cries:

> The minister of defence should have his photograph taken for a recruiting poster, in the pose of Kitchener in the First World War, pointing his finger and saying, 'Your Country Needs You,' with a second slogan [referring to one of the later Leete recruitment posters] 'See the World at Government Expense – and after 25 years' service return to National Assistance.'

But the biggest outing of the period for the pointing Kitchener was yet to come. His face became an icon of the Swinging Sixties – a usage by an anti-establishment youth throwing off the grey austerity years of the previous decade that would shock the older generation. The catalyst may well have been Joan Littlewood's 1963 anti-war musical *Oh! What a Lovely War*. This was initially staged at the Theatre Royal Stratford and then moved into Wyndham's Theatre in the West End, despite protests from the family of Earl Haig – and the Lord Chamberlain's office, which, until 1968, had the power to censor plays or prevent them being shown altogether. The play used Leete's artwork as a stage backdrop and copies were posted on the walls of theatres – putting it at the very front of an attack on the British establishment and condemning the Great War. The play also drew on *The Donkeys*, Alan Clark's 1961 study of the war that took its title from the phrase 'Lions led by donkeys'. At the end of 1964, Littlewood's play had a three-month run on Broadway and, in 1969, Richard Attenborough's film of *Oh! What a Lovely War* was released, starring Dirk Bogarde, Laurence Olivier and Vanessa Redgrave. The LP record of the soundtrack uses a version of Leete's image on the cover. The anti-war

message of the play and film allied to the Kitchener image on both sides of the Atlantic chimed with the peace message of the Hippy movement and fed into the protests against the Vietnam War.

Kitchener's face was definitely in the air once again. I Was Lord Kitchener's Valet was a market stall and boutique in London's Portobello Road and then at the centre of the Swinging Sixties culture of Carnaby Street in 1966. The shop claimed to be London's first second-hand shop selling 'kinky, period and military gear' such as uniforms, silk shirts and 'pop art' Union flags (Figure 84). Robert Orbach, a director of the shop, says the name was thought up by Ian Fisk, one of the founders:

... just because we sold Victoriana. It conjured up images of Edwardian smoking jackets, top hats and canes and Birdcage Walk on Sunday – pure nostalgia. All of a sudden more people were in there than in the rest of Carnaby Street. With incense burning, it was great, like paradise, you didn't know who was going to walk through the door.

Figure 84. Advertisement for London boutique I Was Lord Kitchener's Valet

In fact, the cream of the pop world came through the doors. Eric Clapton bought a military jacket early in 1966 and was soon followed by John Lennon, Mick Jagger and Cynthia Lennon. Jagger bought a red Grenadier guardsman drummer's jacket and wore it on ITV's *Ready Steady Go* when the Rolling Stones performed 'Paint it Black'; next morning there were queues around the block. The shop's sign – a rendition of Leete's image in colour by painter Pat Hartnet – has been credited with inspiring pop artists Peter Blake and Jann Haworth with the idea for the uniforms on the Beatles' *Sgt. Pepper's Lonely Hearts Club Band*. Hartnet's painting is held by the Victoria and Albert Museum.

Kitchener - The Man, the Poster and the Legacy

As a result of the exposure, officers' tunics dating from the Great War sold by Lord Kitchener's Valet became an essential component of the Psychedelic style and were worn by both the Beatles and Jimi Hendrix. The shop became an influential venue and featured in contemporary documentary photographs and film footage. *Men Only* magazine ran a feature about the boutique in its May 1967 issue. Leete's Kitchener image was used on colour posters promoting Carnaby Street to tourists. The shop opened branches in Piccadilly Circus and then Chelsea's trendy King's Road, where it was called I Was Lord Kitchener's Thing. Again, Kitchener's face was prominent in the shops, as well as on a range of souvenirs.

The military look appeared again in the 1980s, with singers such as new romantic Adam Ant wearing military garb. In 1994, the Victoria and Albert Museum held an exhibition, Streetstyle, and later published a book on the topic, *Surfers, Soulies, Skinheads & Skaters* covering fifty years of subcultural styles.

In the United States, the Flagg derivative of Leete's drawing was used for similarly rebellious purposes in the form of underground propaganda against the Vietnam War at the end of the Sixties. One version was headlined 'Uncle Sam needs YOU nigger'. The text included: 'Fight for freedom in Vietnam… Die Nigger Die – you can't die fast enough in the ghettoes. So run to your nearest recruiting chamber!' *Uncle Sam Wants You Dead, Nigger* was a 1971 play by Richard Pryor. Two other prominent anti-war posters show Uncle Sam replaced by a bandaged, blood-stained version of himself and then by a skeleton.

In 1968, the Leete poster was revived for another purpose in Britain, but one that might have met with more sympathy from Kitchener himself. The Back Britain campaign aimed to encourage people to buy domestic goods. Posters went up on 17,000 hoardings with Kitchener on a Union flag background, but with the challenging finger turned around and the caption: 'I'm backing Britain – Will you?' For the columnist Anne Scott-James writing in the *Daily Mail* the next day the campaign was creepy:

> To invoke Lord Kitchener – an arch imperialist, a foul personality, a man
> who quarrelled with politicians, viceroys, officers and men, and who

had the Mahdi's head made into an inkstand – is to revive the crassest attitudes of World War I … Let's hope the Kitchener campaign will be laughed out of court, for the British have grown up since 1914 and remained wonderfully civilised through all the agonies of World War II.

Scott-James was one of Fleet Street's most experienced journalists, having been woman's editor on *Picture Post* during the war, editor of *Harper's Bazaar* and a star columnist on the *Sunday Express*. She was married to Osbert Lancaster, who had designed the jacket for Magnus's 1959 Kitchener biography. Her mention of the Mahdi's head refers to the 1899 controversy over the desecration of the Sudan rebel's tomb. The 'your country needs you' phrase was also called up to appeal for more exports (1975), to encourage people to holiday at home (1989) and as part of an attack against the profligate cost of the Conservative government's publicity campaigns to encourage privatisation (1989).

On 1 February 1980, Jonathan Aitken, the Conservative MP who would later be jailed for perjury and perverting the course of justice after claiming to wield the 'sword of truth' against the *Guardian* newspaper, puts his own version of history on the parliamentary record:

My honourable friend the member for Woking made a ringing cry for a register of volunteers. We have tried that once this century, and it was a disaster. It may be that in the rosy hue of historical memory one thinks of Kitchener's efforts to raise volunteer armies as a great success. In a way, it was. A poster saying 'your country needs you', with a good photograph, encouraged more than two million men to register for the Colours. But one tends to forget more than sixty years later that Lord Kitchener's nickname at the time was 'K of chaos', because the volunteer armies led to far greater muddle and inefficiency and, incidentally, created a much nastier atmosphere with young girls presenting white feathers to men who had tried to enrol but could not do so. The volunteer system of call-up failed in the First World War and, in the end, it had to be replaced by national service and conscription.

Kitchener - The Man, the Poster and the Legacy

Notice the description of the photograph with the phrase, an incorrect version of events that encapsulates the way people have confused the many versions of the Kitchener poster.

A better gloss on the slogan was provided by Maurice Saatchi, one of the founders of Saatchi & Saatchi, the advertising agency that created the 1979 general election poster for the Tories attacking their great rivals, 'Labour isn't working'. In a 1996 Lords debate on the role of the media in a democratic society, Lord Saatchi tells the house:

> The great communicators in history have always made things simple: 'Your country needs you', 'No taxation without representation' or, 'One man, one vote'. These are not just slogans; they encapsulate whole philosophies, aspirations and political systems.

In 1998, the Victoria and Albert Museum returned to the subject of posters, hosting an exhibition and publishing an accompanying book by Margaret Timmers, *The Power of the Poster*. The book makes reference to research by the government into the best type of posters just before the start of the Second World War, when a member of the public suggests the text-only posters would be enlivened by an image and cites the example of the Kitchener posters.

The Army Careers Office also returned to the iconic Leete image in the late 1990s for a campaign that aimed to encourage more ethnic officers to join the forces. In the posters, Kitchener's face was cut out of Leete's 'Your Country Needs You' artwork and replaced by that of Ashok Kumar Chauhan, a warrant officer, and Ghanaian-born Captain Fedelix Datson, both of the Royal Artillery. Following accusations of racism within the forces in the mid-1990s, the new Labour government had insisted on a pro-active recruitment campaign and percentage quota targets. This contributed to a slow rise in the number of ethnic minority recruits; from less than one per cent in 1996-97 to about two per cent in 1999-2000, and almost six per cent in 2002.

Figure 85.

Kitchener image used to promote the online *Times* archive

As technology made it cheaper and quicker to reproduce images, with cheaper printing and photocopiers, and then widespread computers and the web, Leete's image was used for a wide variety of purposes, from publicising village fetes to jumble sales and garage sales. Alongside these amateur examples, the *Daily Mirror* ran a front page of a pointing Tony Blair with the headline 'Your country needs him' on the day of the general election. It was the first of three election victories for Tony Blair. To promote the launch of its online archive of articles going back to 1785, the publisher of *The Times* and *The Sunday Times* turned to Leete's Kitchener image alongside an illustration of the sinking *Titanic* for its promotional material (Figure 85). In another example, David Cameron evoked the 'Your country needs you' mantra to launch his 'Big Society' idea in 2010, so the *The Sunday Times* overlaid the prime minister's face on the Leete image, as Figure 86 shows.

In between these uses in newspapers, in 1999, the advertising industry magazine *Campaign* identified Leete's Kitchener poster as the second best poster of

the century after Saatchi & Saatchi's 'Labour isn't working'. Three years later, the same magazine nominated the Leete poster as 'the best recruitment advert of all time'. Eric Field was identified as the copywriter, Leete the illustrator and Caxton the agency for the various versions. Such was the fame of the poster that it was the subject of many articles and television programmes, including a History Channel documentary, *A Small Piece of History*, in 2003.

And Leete's image, or variations on his theme, has been seen on many magazine covers since the start of the new century. These include titles as varied as *Dr Who Magazine*, *Brain Damage*, *The Economist* (Figure 87), *Radio Times* (at least twice) and *Military History*. The music monthly *Mojo* also adopted the Leete image for a CD cover, with tracks based on The Beatles' *Sgt. Pepper's Lonely Hearts Club Band*.

The fifth edition of the book *Propaganda and Persuasion* by two US academics, Garth Jowett and Victoria O'Donnell, uses a derivative of the Leete image on the cover but, strangely, does not mention Leete in

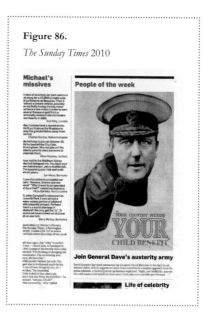

Figure 86.

The Sunday Times 2010

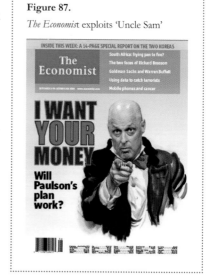

Figure 87.

The Economist exploits 'Uncle Sam'

Figure 88.

Sky advertises its series
Meet the Chickens

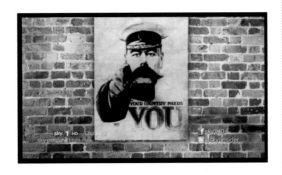

its index. And the British Library reproduced Leete's image on its souvenirs for the 2013 exhibition *Propaganda: Power and Persuasion,* though it used one of the early derivatives, James Montgomery Flagg's Uncle Sam variant, for the main promotional posters, presumably because of its more colourful artwork. In the same year, a wartime sitcom series, *Meet the Chickens,* used Leete's image used to evoke the conflict in its promotional material (Figure 88).

Just as in the Victorian and Edwardian eras, a souvenir industry built up around Kitchener remains very much alive and well especially following the centenary of the commencement of the Great war in 2014. Tea-towels, cushions, mugs, badges, posters, mouse mats, watches, wash bags, T-shirts and mobile phone covers can be brought on the web and in shops based on copies of, or redrawings of, Leete's rendition of the military hero. Many of these are humorous, such as 'I want you to pull my finger' or 'Your pub needs you' but just as many celebrate Kitchener as a historic figure or mark the war. In 1999, Royal Doulton issued a limited edition jug to mark the sesquicentenary of Kitchener's birth, with the handle depicting poppies and a version of the poster.

20

The truth about
the Kitchener posters

Recollections of events and situations that occurred nearly a century ago can be remote from actuality. The aim of this book has not been to credit or discredit the claims of others but to bring together the theories that have been proposed over the years and review them. The result is, we hope, a more realistic idea of the man Kitchener and how he became indelibly linked to a poster. In researching the man through his poster we have compiled the most complete and up to date picture of the events and life of this iconic poster itself.

There is little doubt that the 'Kitchener' poster is an icon of the First World War. The words on the poster were both 'Britons. [Kitchener] Wants You' and the more referred to 'Your Country Needs You', which appeared on the front of the *London Opinion* in 1914 and later on a poster by the printer David Allen. Yet, even the venerated British Library has taken up the idea of the poster as a myth on its The Great War centenary website. Under the head-line '"Your country needs you" advertisement' and Leete's artwork, it states:

Nearly half a million joined up between 4 August and 12 September, including 33,204 on 3 September alone. A key factor in stimulating enlistment was locally-raised 'pals' battalions ... This image, designed by Alfred Leete (1882–1933), and famous for Kitchener's pointing finger and the words 'Your Country Needs You', has become an icon of the enlistment frenzy. However, it did not appear in poster form

until the end of September 1914, after signing-up peaked. Its supposedly vital influence on recruitment is largely a myth. Though 2.5m men joined the British army voluntarily between August 1914 and December 1915, even this was not enough to supply the front line, and conscription had to be introduced in January 1916.

Such statements need unpicking. First, the image was not an advertisement, it was an editorial magazine cover. It has come to represent the two-year volunteer recruitment campaign, and the Great War itself, but who turned it into 'an icon of the enlistment frenzy' is unclear. It appeared as the *London Opinion* cover, dated Saturday, 5 September 1914, but probably in the shops a few days before, and this was in the middle of the enlistment frenzy that Simkins identifies as peaking the Friday afterwards. Yet, the British Library dismisses whether it had much effect, even though the magazine had sales that have been estimated at between 100,000 and 300,000 copies. This is before any official posters even carried images. As the British Library states, by mid-September half a million men had enlisted – but although the 'frenzy' was coming to a peak, two million more would subsequently join up. To dismiss the image's influence when it appeared on a popular magazine cover during that frenzy, seems presumptuous. Not only that, the image is distributed again by the magazine as a poster (Figure 89) a few weeks later.

Indeed, the repetition a number of times by *London Opinion* – which must have amounted to more than a million copies of the image being

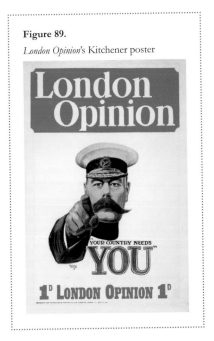

Figure 89.

London Opinion's Kitchener poster

distributed in a few months – can only have magnified its influence. This is not to diminish the general recruiting campaign, the effect of which can be estimated, but the influence of a single piece of artwork used many times is impossible to enumerate. If the effect of Leete's image is a 'myth', why was it repeated so often and so quickly? Why do so many commentators refer to Kitchener's pointing finger? And why does Stefan Lorant, one of the most brilliant photojournalists of his generation, put Leete's artwork on the front of *Picture Post* in the darkest days of the Second World War in 1940?

We have referred to claims about the exposure and effectiveness of the Leete poster during the war. It was never officially sanctioned, there are no contemporary records of its use or effect as a recruiting aid, and there was another, official Kitchener poster with an image of the great man. So it might be easy to arrive at the conclusion that the Leete poster was a bit on a non-event. However, as we have shown, there is evidence that it was well known at the time and, indeed, it was copied by other nations.

At the end of the Great War, if not before, all posters will have been removed and within a few years faded in the public's mind as happier days seemed to lie ahead. The poster based on Alfred Leete's artwork was not one of the most numerous of the recruiting posters; in fact, it is well down the scale in terms of numbers printed. However, this poster, out of hundreds of others, has survived in the collective memory and it alone has become an icon of the First World War.

We have seen that Alfred Leete may have based his image on a contemporary cigarette advertisement or indeed other posters bearing a similar image, but most graphic designers exploit previous images. Indeed, the technique of direct eyes has been used in religious and other paintings to good effect for millennia and few people observing the poster would have failed, consciously or sub-consciously, to have made a connection between Kitchener and God. Similarly, the foreshortened arm to link observer and image has been used to powerful effect in religious paintings. The exaggerated black moustache in the very centre of the image draws attention to the poster and the position of the

face in the middle of the frame mimics religious iconography. Leete, knowingly or unknowingly, brought together some of the most powerful techniques of artists throughout history to force the observer to feel the effect of his design.

The poster campaign eventually fizzled out. By 1916 the British public was skilled in resisting the power of commercial advertising and simply transferred to the recruiting campaign the ironic detachment that had developed from years of exposure to the inflated claims of products such as Rowntree's Cocoa, Pears' Soap and Colman's Mustard. However, if we detach ourselves from the horrors of the war and concentrate on the designs, the recruiting campaign produced colourful imagery that has remained with us and certainly influenced design today.

This powerful sketch by Leete is said to have been completed within a day. The result – the poster 'Your Country Needs You' – is now famous and part of our 'mental furniture'. A century later, Kitchener is better known for his image on a poster than for his martial pursuits. Within a few years of the poster's appearance, the comment 'A poor general, but a wonderful poster' was supposedly made of him. In our minds we associate Leete's image and words with the First World War and it has been assimilated into our own partial vision of the conflict. None of us is sure whether it is the eyes, the finger or the words themselves; we don't know if it is the image or the associations connected to it that stir us, but the effect remains as powerful today as it obviously was a century ago – so much so that the image, almost unaltered, has been re-used thousands of times over the years and no doubt will continue to inspire people, knowingly or unwittingly, for decades to come.

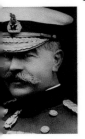 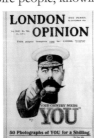 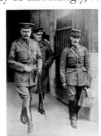 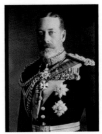 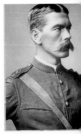

Timeline

1882

28 August.
Alfred Leete born
in Northampton

1885

Kitchener shown on
a postcard of a pho-
tograph by Alexander
Bassano (1)

1897

Leete's first published
drawing in the *Daily
Graphic*

1899 - 1902

Boer War in
South Africa (2)

1905

22 November.
Leete's first cartoon
for *Punch* published

1906

Advertisement for
BDV cigarettes (3)

1912

17 January.
Scott and four others

reach the South Pole
but die on the return
journey

1914

15 January.
Caxton recruitment
advertising starts in
national papers

4 August.
Britain declares war
on Germany (4)

5 August.
First wartime re-
cruiting advert: Eric
Field's 'Your King and
Country need you' (5)

7 August.
Kitchener appeals for
100,000 men (6)

2 September.
Punch magazine prints
cartoon poster (7)

5 September.
London Opinion's 'Your
Country Needs YOU'
cover by Leete (8)

5 September.
Daily Mail Starts ad-
vertising for recruits

26 September.
Colliers Weekly The

Germans are Coming
(9)

14 November.
London Opinion skit on
Leete's cover (10)

PRC's first poster
using an image of the
British Isles (11)

Army recruiting
stations and official
offices display posters
(12)

November.
PRC poster 'Britain's
new million army'
(13)

Leete began to
publish his Schmidt
the Spy drawings in
London Opinion (14)

1915

July.
PRC produces the
'official' Kitchener
poster (15)

One of several
'Remember Belgium'
posters by the PRC
(16)

PRC poster uses the
Leete image (17)

Cigarette cards of the
PRC's posters. Leete's
image is not used (18)

September.
PRC's poster cam-
paign suspended

Gale and Polden
postcard by Sid A.
Potts shows a boy
running away from
a smashed window
with the words 'Please
Sir! I didn't break it!!'
Beside the window,
Kitchener points out
from a poster with
the words 'It's you I
want!'

1916

February.
Artist Will Scott
portrays K of K as a
battleship for a cover
caricature on *Drawing*
magazine

March.
Conscription comes
into force under
Military Service Act
for unmarried men
aged 18-41

Leete's *Schmidt the Spy*
made into a film

Martyn Thatcher & Anthony Quinn

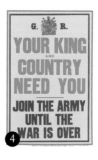

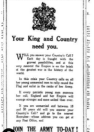

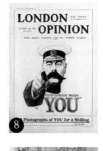

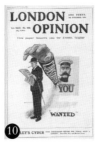

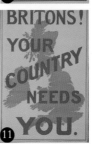

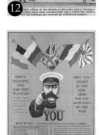

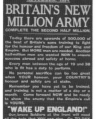

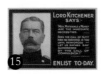

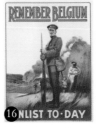

Kitchener - The Man, the Poster and the Legacy

Leete joins the Artists Rifles. Sees action in France in 1917 and 1918 (19)

June.
Kitchener lost at sea

6 July.
Leslie's Weekly magazine carries a US version of Leete's cover by James Montgomery Flagg (20)

13 July.
Flagg's Uncle Sam is used for advertising in *Leslie's*

1917

15 February.
Leslie's again uses Flagg's Uncle Sam with the words, 'I Want You'

5 March.
War cabinet approves the creation of a national war museum. Later becomes the Imperial War Museum

6 April.
US enters war

19 April.
Flagg joins volunteers on US pictorial publicity committee

Flagg's Uncle Sam used for a US army recruiting poster (21)

29 December.
A variant of Flagg's image for *Leslie's* with

a pistol-toting Uncle Sam

1917-20

Leete's concept used by the USSR, Germany, Italy and other nations as a recruiting poster and to help raise funds for their war efforts (22)

1918

11 November.
War ends with armistice Leete's 'Masbadges' in the *Sketch* of animal mascots combined with regimental badges

1920

9 June.
Imperial War Museum opened in the Crystal Palace by George V

1921-22

Lord Esher biography of Kitchener. Asquith, former prime minister, defends Kitchener

1933

17 June.
Leete dies in London, aged 51

1936

Leete's book, the *Work of a Pictorial Comedian* published

7 July.
The Duke of York, later George VI, opens Imperial War Museum on present site in South London

1939

3 September.
Britain declares war on Germany

1940

1 June.
Picture Post uses Leete's artwork for its cover in the week of the Dunkirk rescue (23)

1949

George Orwell's *Nineteen Eighty-Four* published

1955

19 January.
Punch portrays Kitchener with the words 'Your country no longer needs you' for Sudan civil servants (24)

19 March *Picturegoer* magazine uses a Leete-style image to promote its Vote for Your Stars competition

Daily Telegraph magazine uses Leete artwork as one of eight iconic images of the past century (25)

1958

Philip Magnus biography of Kitchener includes the Leete artwork (26)

1961

July 14.
Daily Mail ridicules Harold Macmillan, the prime minister, as Kitchener (27)

1962

Jump Up records releases 'Love in the Cemetery', the first of several singles by the reggae/calypso band of Lord Kitchener, who had arrived in Britain the MV Windrush in 1948

1963

Joan Littlewood's anti-war musical *Oh! What a Lovely War* staged in London using Leete's imagery

1964

Oh! What a Lovely War staged on Broadway from 30 September 1964 to 16 January 1965 (28)

I was Lord Kitchener's Valet uses posters and shop sign based on Leete's image (28)

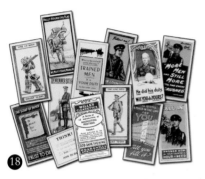

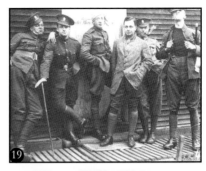

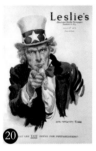

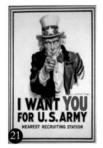

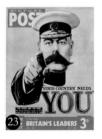

Kitchener - The Man, the Poster and the Legacy

Leete's Kitchener image becomes an icon of youth culture

1966

July 16. Image of the poster in *Look and Learn* issue number 235

1967

Young women's magazine *Honey* runs a front cover of a woman in a Kitchener pointing pose (29)

1968

I Was Lord Kitchener's Thing boutique opens in London's King's Road

1969

Richard Attenborough's film of *Oh! What a Lovely War*. The LP of the soundtrack uses a version of Leete's image on the cover

1971

Flagg's poster used for Vietnam War protests in the US

1972

Psycho film director Alfred Hitchcock is photographed at the Cannes film festival in a Kitchener pointing pose. There are also photographs of him on set in 1926 striking a similar pose (30)

21 October. The comic *Valiant and TV21* uses illustration based on Leete artwork for a Kitchener quiz on its cover (31)

1980

US president Ronald Regan is photographed in a Kitchener pointing pose

1981

French magazine *Histoire* runs the Leete artwork for its cover feature: 'Kitchener: un mort mystérieuse'

1989

Brain Damage, a 'comic for grown-ups' portrays a rabid 'Lord Wildtrouser' on its cover as a grotesque rendering of Kitchener (32)

1990

Advertising for the National Lottery is based around a giant pointing hand with the words 'It could be you'

1991

Bhangra group DCS's single 'Rule Britannia' released by Punch Records. The sleeve portrays a Kitchener-like Punjabi man in a turban of the Union flag (33)

1992

The 150th anniversary issue of the *Illustrated London News* uses a redrawn, colour version of Leete's image on its cover

1997

15 January. To mark the 50th anniversary of *Der Spiegel* (*The Mirror*), founding editor Rudolf Augstein has his photograph taken in a pointing pose with a blown-up photograph of the first cover behind him. The German news weekly was set up by the British authorities after the war

1 May. *Daily Mirror* front page of a pointing Tony Blair with the headline 'Your country needs him' on the day of the general election

First army campaign aimed at recruiting ethnic minority officers with Kitchener's face replaced by black and Anglo-Asian officers (34)

1999

15 October. PRC's Caxton/Leete/Field poster voted second best poster of the century

2002

21 August. The cover of *Doctor Who* magazine portrays the character Brigadier Lethbridge-Stewart pointing from the cover with the words 'We want you as a Who recruit!' (35)

17 December. PRC's Caxton/Leete/Field poster named best recruitment advert

2003

February: BBC *History* magazine uses Leete's image for its 'The eyes have it: the untold story of history's most powerful persuader'

TV documentary draws on Field's diaries of him writing

Martyn Thatcher & Anthony Quinn

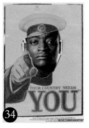

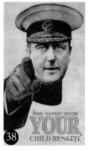

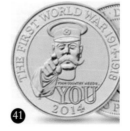

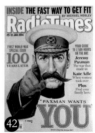

the slogan 'Your country needs you'

2008

September.
The Economist cover of US Treasury secretary Henry Paulson based on Flagg artwork (36)

October.
Composer Andrew Lloyd Webber mimics Kitchener's pose to gain publicity for his attempt to win the Eurovision song contest

2010

The Times & The Sunday Times use the image on their new website (37)

6 October.
David Cameron invokes Leete's words in a speech on his 'Big Society' theme

9 October.
Sunday Times montage parodies Cameron's speech (38)

2013

February.
Military History reproduces Leete's image on its covers for the feature 'Kitchener's volunteers and the slaughter on the Somme' (39)

13 July.
Radio Times has Lord Sugar on its cover in a Kitchener pose for *The Apprentice* TV series (40)

3 August.
Daily Telegraph headline: 'Kitchener's famous pointing finger was never on a war poster'

2014

Anniversary of the start of the Great

War, countless number of 'Your Country Needs You' images used in the publicity and documentation

The Royal Mint issues a £2 commemorative coin based on Leete's artwork (41)

British Library's The Great War website: Leete image's 'supposedly vital influence on recruitment is largely a myth'

January 25
Radio Times portrays Jeremy Paxman as Kitchener to front its centenary programming (42)

May 4.
Event, the *Daily Mail*'s Saturday supplement, commissions Ralph Steadman to interpret Leete's image in the 'gonzo' style he developed for the

Rolling Stone articles and books of Hunter S. Thompson

Several newspaper cartoonists use variants of Leete's image. Peter Brookes in *The Times* replaces Kitchener with Israeli prime minister Benjamin Netanyahu (August 5). (43)

In the *Guardian*, Steve Bell has a similar idea for a caricature of British prime minister David Cameron (21 October) (44)

2015

The website Find My Past uses a photograph of Kitchener in its online advertising banners (45)

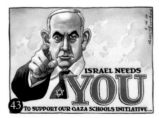

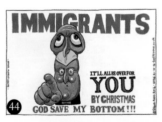

Martyn Thatcher & Anthony Quinn

Table 1. The main variants of the Kitchener poster

	Name	Approx. date	Publisher	Evidence of use	Comment
Figure 89	*London Opinion* Kitchener poster	September 1914	*London Opinion* magazine		The first 'Your Country Needs You' Kitchener poster
Figure 59	'Britons [Kitchener] wants you'	October 1914	Victoria House Printing Co, with *London Opinion* permission	Trimmed version on Ulster tram (Figure 66) Chester Barracks photograph (Figure 65) Liverpool Exchange Station, December 1914 (Figure 67)	Examples in the IWM, State Library of Victoria and the Robert Opie Collection. Copy sold in 2014 for £27,450
Figure 68	'Your Country Needs You' flags poster	November 1914	David Allen & Sons, printers, number 0200	Lusitania survivors photograph, May 1915	Has no PRC number. Credit to *London Opinion* beneath K's collar
Figure 64	Official Kitchener poster PRC 113	September 1915. Words based on a speech made on 9 July 1915	Parliamentary Recruiting Committee	Documented at the IWM A *Punch* cartoon from 17 November 1915 shows a similar Kitchener face on part of a poster in a recruiting office	Uses a coloured Bassano photograph from 1899

Acknowledgements

The authors wish to thank:

Peter Doyle, author of *The First World War in 100 Objects* and many other books on the Great War, for his helpful comments on the manuscript

Lady Kenya Tatton-Brown (née Kitchener) for her Foreword and permission to quote a private conversation

Paul Atterbury for permission to use email content

Stephen Bradley for his research into the Ulster tram photograph

Cheltenham Art Gallery for permission to use the A. Davies portrait of Lord Kitchener

Chester Army Museum for permission to use photographs from their archives

Great War Forum members for three years of advice and support (www.1914-1918.net)

Henry's Military Collectables for the use of the Kitchener doll image

Imperial War Museum London for permission to use original Leete artwork (IWM_PST_002735) and the poster (IWM_PST_0414)

James Taylor, author of *Your Country Needs You*

National Portrait Gallery for permission to use Kitchener portrait (MW112299)

National Railway Museum, Science & Society Picture Library for permission to use the photograph of Liverpool Exchange Station

Nicholas Hiley: permission to quote from his essay 'Kitchener Wants You and Daddy what did YOU do in the Great War?: the myth of British recruiting posters' *Imperial War Museum Review*, No. 11

Richard Slocombe, senior curator of art at the Imperial War Museum

Nest Egg Antiques for permission to use Wilkinson Staffordshire Kitchener Toby jug photograph

List of illustrations

Bibliography

Buckley H. (1930) 'Advertisement for Great Event', *Times*, November 28

Albrinck M. (2009) 'Humanitarians and he-men: recruitment, posters and the masculine ideal imaginings of war' in James P. (ed) *Picture This: World War I posters and visual culture*, University of Nebraska

Allen W.E.D. (1957) *David Allens: The history of a family firm 1857-1957*. John Murray

Anon. (1914) 'Lord Haldane or Lord Kitchener?' *Times*, 5 August

Anon. (1914) 'War Comments', *Bystander*, 16 September

Anon. (1914) 'Uniformed already – and reviewed', *Bystander*, 30 September.

Anon. (1914) *L'Illustration*, 21 October 1914

Anon. (1914) 'What damps recruiting ardour' (cartoon), *Bystander*, 14 November

Anon. (1915) 'Lord Kitchener and the Suffragists', *Times*, 25 January

Anon. (1916) 'The memorial service for Lord Kitchener', *Sphere*, 17 June

Anon. (1949) 'Picture Gallery', *Times*, 22 November

Anon. (1959) 'Doing what comes naturally', *Daily Mail*, 5 February

Anon. (1961) 'The same old clichés won't do this time, Harold', *Daily Mail*, 14 July

Anon. (1968) 'I'm backing Britain – Will You?' *Daily Mail*, 24 January

Anon. (1999) 'Poster advertising awards 1999 (poster of the century)', *Campaign*, 15 October

Anon. (2002) 'The 10 best recruitment ads of all time', *Campaign*, 17 December

Anon. (2005) 'Kitchener of Khartoum: Mason extraordinary.' *MQ*, 12 January

Anon. (accessed July 2015) 'History: Cases from the National Archives – Carl Hans Lody'. www.mi5.gov.uk/home/about-us/who-we-are/mi5-history/mi5s-early-years/carl-hans-lody.html

Asquith H.H. (1921) 'An appreciation of Lord Kitchener', *Pearson's*, December (continued in Feb 1922)

Aulich J. and Hewitt J. (2007) *Seduction or Instruction? First World War Posters in Britain and Europe*. Manchester University Press

Bairnsfather B. (1915) 'Where did that one go to?' (cartoon), *Bystander*, 31 March

Barkham, P. (2005) 'Navy's new message: your country needs you, especially if you are gay', *Guardian*, 21 February, p3

Barr R. (2000) *The Cheshire Regiment*, History Press

Baumer L. (1916) 'Mr Punch's wartime revue' (cartoon), *Punch*, 5 July

Brex T. (1914) *Scare-mongerings from the 'Daily Mail' 1896-1914: The paper that foretold the war*. Daily Mail Publications

Bridgewater H. (1910) *Advertising; or, the art of making known*. Pitman

British Library (2014) '"Your country needs you" advertisement.' Accessed 3 November 2015. www.bl.uk/collection-items/your-country-needs-you

Browne T. (1910) *In Other People's Shoes*. Lang

Bryant E.M. (1915) 'His call to Arms', *Windsor*, May

Buckley H.H.C. (1930) *Great Event*. Figurehead

Martyn Thatcher & Anthony Quinn

Buller T.F. (1971) *O'r Wyrcws I Baradwys*. Dinbych, Denbigh: Gwasg Gee

Cartoon Archive, University of Kent, www.cartoons.ac.uk

Church H. (1934) 'Was Kitchener's body found?', *Pictorial Weekly*, 31 March, pp2-4

Churchill W. (1899) *The River War*. Longman

Daily Telegraph (1955) 'Britain at War: Kitchener's call for recruits', *100 Years in Pictures: Centenary supplement to the Daily Telegraph*

Dark S. (1922) *The Life of Sir Arthur Pearson*. Hodder & Stoughton

Darracott J. and Loftus B. (1972) *First World War Posters*. Imperial War Museum

Davies R. (1990) *Ronald Searle*. Sinclair-Stevenson

Davray H.D. (1916) *Lord Kitchener: His work and his prestige*. T. Fisher Unwin

Denny F. (2013) Encyclopædia of the British Music Hall. www.oldtimemusichall.net/chirgwin.htm

Dodds E. (1918) 'The all clear boys', *Pearson's*, August

Doyle P. (2014) *The First World War in 100 Objects*. Stroud: The History Press

Dudley A. (1916) *Valediction: Sonnets to Kitchener*. Arthur L. Humphreys

Ferguson N. (2001) 'A walking, talking ramrod?', *Sunday Telegraph*, 19 February, p11

Esher R. (1921) *The Tragedy of Lord Kitchener*. John Murray

Evors E.M. (1916) 'Wounded soldiers making wooden soldiers', *Graphic*, November 18, p632

Field E. (1914) 'What the Army offers' (advertisement), *Daily Mail*, 15 January

Field E. (1959) *Advertising: The forgotten years*. Ernest Benn

'Fougasse' (Cyril Bird) (1916) 'War's brutalising influence' (cartoon) *Punch*, 19 July

Gaunt W. (1961) 'Posters as an open air art gallery', *Times*, 21 June

Gifford D. (2004) 'Obituary: Norman Thelwell', *Guardian*, 10 February

Ginzburg C. (2001) 'Your country needs you: a case study in political iconography', *History Workshop Journal*. No. 52

Gombrich E.E. (1960) *Art and Illusion. A study of the psychology of pictorial representation*. Phaidon

Goulborn K. and Jackson G. (1988) *Chester: A second portrait in old picture postcards*, SB Publications

Graves C. (1939) 'I see life' (Sandy's Autograph Bar), *Daily Mail*, 28 February

Hall S.R. (1915) *Writing an Advertisement*. Boston, MA: Houghton Mifflin

Hardie M. & Sabin A.K. (1920) *War Posters Issued by Belligerent and Neutral Nations 1914-1919*. A&C Black

De La Haye A. and Dingwall C. (eds) (1996) *Surfers, Soulies, Skinheads and Skaters: Subcultural style from the forties to the nineties*. V&A Publications

Henty G.A. (1903) *With Kitchener in the Soudan: A story of Atbara and Omdurman*. Blackie

Hickling P.B. (1915) 'During a Zeppelin raid' (cartoon), *Punch*, 17 November

Hiley N. (1987) 'Sir Hedley Le Bas and the origins of domestic propaganda in Britain 1914-17', *European Journal of Marketing*, Vol. 21 No. 8

Hiley N. (1997) 'Kitchener Wants You and Daddy what did YOU do in the Great War?: the myth of British recruiting posters', in Smith K & Simkins P (eds) *Imperial War Museum Review*, 11, pp 40-58

Hyde M. (1972) *The Other Love: An historical and contemporary survey of homosexuality in Britain*. Mayflower

Hyam R. (1991) *Empire and Sexuality: The British experience*. Manchester University Press

History Channel (2003) *A Small Piece of History*, 16 February (broadcast)

James P. (ed.) (2009) *Picture This: World War I posters and visual culture*, University of Nebraska

Jones-Edwards W. (1963) *Ar Lethrau Ffair Rhos*. Aberystwyth: Atgofion Mwnwr, Cymdeithas Lyfrau Ceredigion Gyf

Kitchener - The Man, the Poster and the Legacy

Jowett G.S. and O'Donnell V.J. (2012) *Propaganda and Persuasion*. New York: Sage

Judd D. (2011) *Empire: The British imperial experience from 1765 to the present*. IB Tauris

Kirkwood P.M. (2012) 'The impact of fiction on public debate in late Victorian Britain: the Battle of Dorking and the "lost career" of Sir George Tomkyns Chesney', *Graduate History Review*. Vol. 4, no. 1

Koenderink J.J. et al. (2004) 'Pointing out of the picture', *Perception*. No. 33

Laffin J. (2011) *Tommy Atkins: The story of the English soldier*. Stroud: History Press

Le Bas H.F. (1917) *Lord Kitchener Memorial Book*. Hodder and Stoughton

Leete A. (1914) 'Get out and get under' (cartoon), *Bystander*, 26 August

Leete A. (1929) 'Mr York of York, Yorks' (animated commercial). British Publicity Talking Films for Rowntree http://yorkshirefilmarchive.com/film/mr-york-york-yorks

Levine J. (2008) *Forgotten Voices of the Somme*. Ebury Press

MacDonagh M. (1935) *In London During the Great War: The diary of a journalist*. Eyre and Spottiswoode

Magnus P. (1958) *Kitchener: Portrait of an Imperialist*. John Murray

Macqueen-Pope W. (1957) 'Personalities of the old London office', in Allen (1957)

Manchester Guardian (1915) *History of the War*. John Heywood Manchester (figs 47 & 75)

Messinger G.S. (1992) *British Propaganda and the State in the First World War*. Manchester University Press

Mitchell W.J.T. (2008) 'Visual literacy or literary visualcy?', in Elkins J. (ed) *Visual Literacy*. New York: Routledge

Murray G. (1940) 'Should they put a laugh in the "don't-talk" drive?', *Daily Mail*, 7 February

Norton J.S. (1918) *The Kitchener Birthday Book*. Samson Low

Oliver, F.S. (2013) *Ordeal by Battle*. Forgotten Books (originally published 1916)

Onslows (2014) 'Onslows achieve a remarkable price for a famous but very rare First World War poster.' www.onslows.co.uk/news.htm

Orbach R. (2006) 'Interview with Robert Orbach' (transcript), February. www.vam.ac.uk/content/articles/i/robert-orbach

Orwell G. (1949) *Nineteen Eighty-Four*. Secker & Warburg

Partridge B. (1916) 'The lost chief' (cartoon), *Punch*, 14 June

Paxman J. (2014) 'The strange death of Lord Kitchener', *FT Magazine*, 7 November

De Pereot M. (1914) 'French soldiers' wives in London', *Daily Mail*, Letters, 22 October

Pincas S. and Loiseau M. (2006) *A History of Advertising*. Cologne: Taschen

Perisco J. (2004) *Eleventh Month, Eleventh Day, Eleventh Hour: Armistice Day, 1918*. New York: Random House

Pollock, J. (1998) *Kitchener: The Road to Omdurman*. Constable

Pollock, J. (2001) *Kitchener: Architect of Victory, Artisan of Peace*. New York: Carroll & Graf

Price M. and Brown H. (1918) 'How to Put in Patriotic Posters the Stuff that Makes People Stop, Look, Act.' National Committee of Patriotic Societies, Washington

Quinn A. (2008) 'London Opinion – the most influential cover', www.magforum.com/mens/london-opinion.htm

Quinn A. (2016) *British Magazine Design Since 1840*. V&A Publishing

Quinn A. (in production for 2016) 'Magazines and periodicals' in *Cambridge History of the Book in Britain*, vol. 7. Cambridge University Press

Rees N. (2011) *Don't You Know There's a War On?* Batsford

Richardson M. (2000) *The Tigers*. Barnsley: Pen and Sword Books

Martyn Thatcher & Anthony Quinn

Richardson F.M. (1981) *Mars Without Venus: A study of some homosexual generals*. Edinburgh: W. Blackwood

Rickards M. (1968) *Posters of the First World War*. Evelyn, Adams & Mackay

Rigney F. (1914) 'The change in Ireland' (cartoon), *Bystander*, 19 August

Saunders N.J. (2001) *Trench Art: A brief guide and history*. Barnsley: Leo Cooper

Scott-James A. (1968) 'Anne Scott-James' column, *Daily Mail*, 25 January

Simkins P. (1988) *Kitchener's Army: The raising of the new armies 1914-1916*. Manchester University Press

Slocombe R. (2010) Interview with the senior curator of art at the Imperial War Museum, July

Sontag S. (1970) 'Introduction' in Stermer D., *The Art of Revolution: Castro's Cuba 1959-1970*. New York: McGraw-Hill

'Spy'(Leslie Ward) (1899) 'Khartoum' (cartoon), *Vanity Fair*, 23 February

Steevens G.W. (1898) *With Kitchener to Khartum*. Edinburgh: William Blackwood

Straus R. (1914) 'Armageddon – in prophecy. How near scare-fictionists have come to the truth', *Bystander*, 19 August

Taylor J. (2013) *Your Country Needs You: The secret history of the ultimate propaganda poster*. Glasgow: Saraband

Thatcher M. (2011) *Myth and Magic: An essay on the iconic Kitchener poster*. Chester: Funfly Design

Thomas B. (1915) 'The tolerated tiger' (cartoon), *London Opinion*, 20 March

Thomas B. (1916) 'A fair exchange' (cartoon), *London Opinion*, 26 August

Thomas B. and Williams W. with Lincoln Springfield (1919) *One Hundred War Cartoons from 'London Opinion'*. London Opinion

Timmers M. (1988) *The Power of the Poster*. V&A Publications

Todd J., Koenderink J., van Doorn A., and Kappers A. (1996) 'Effects of changing viewing conditions on the perceived structure of smoothly curved surfaces', *Journal of Experimental Psychology: Human Perception and Performance*. Vol. 27 no.3

Townsend W.H. (1911) 'Kindred spirits' (cartoon). *Punch*, 20 September

V&A (2002) Posters Study Guide (Bibliography). www.vam.ac.uk/content/articles/p/study-guide-posters

Warby M. (2013) www.brucebairnsfather.org.uk

Watkins O.S (1899) *With Kitchener's Army: Being a chaplain's experiences with the Nile expedition, 1898*. SW Partridge

Wilson A.N. (2003) *The Victorians*. Arrow

Winter J. (2009) 'Imaginings of war: posters and the shadow of the lost generation' in James P. (ed.) *Picture This: World War I posters and visual culture*, University of Nebraska

Woolrich E.F. (1914) 'There is time to finish the game' (cartoon), *Bystander*, 19 August

Zervigón A.M. (2012) *John Heartfield and the Agitated Image*. Chicago Press

Index

Page numbers in *italics* are used for illustrations.